Modern Tribal TATTOO Designs

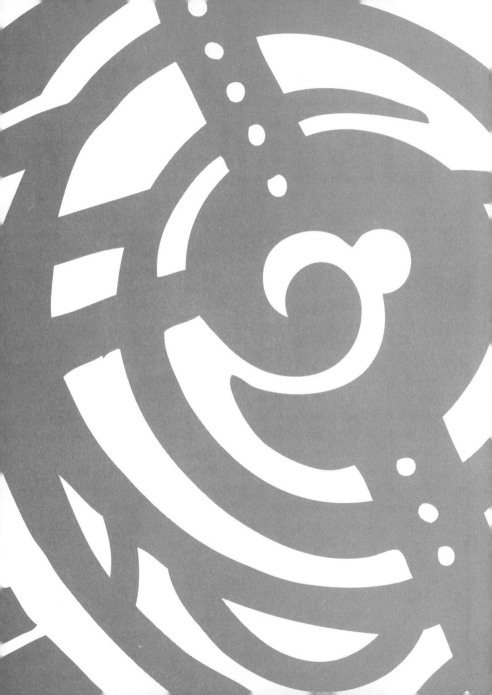

Modern Tribal TATTOO Designs

Lora S. Irish

FOX CHAPEL
PUBLISHING

ISBN 978-1-56523-398-0

Library of Congress Cataloging-in-Publication Data

Irish, Lora S.

 Modern tribal tattoo designs / by Lora S. Irish.

 p. ; cm.

 ISBN: 978-1-56523-398-0

 1. Tribal tattoos. I. Title.

 GT2347.I65 2009

 391.6'5--dc22

2008052243

To learn more about the other great books from Fox Chapel Publishing, or to find a retailer near you, call toll-free 800-457-9112 or visit us at *www.FoxChapelPublishing.com*.

Note to Authors: We are always looking for talented authors to write new books in our area of woodworking, design, and related crafts. Please send a brief letter describing your idea to Acquisition Editor, 1970 Broad Street, East Petersburg, PA 17520.

Printed in the United States of America
First printing: March 2009

Contents

Introduction

For thousands of years, tribes, clans, and the individuals that form them have used tattoos to define their identities and bind them together. Although traditional tribes and family groups are not as prevalent today as they once were, we still have a deep need to be part of distinct social groups. Men and women today create their own clans based on their unique life experiences, educational levels, interests, and activities. The resurgence of tribal tattoo art is part of this trend.

Our ancestors faced the dangers and challenges of their natural settings—weather, predators, and disease—buffered by their tribe, traditions, and spiritual teachings. They found their identities through their family's history of achievements, their occupations and skills, and their own accomplishments.

When a person reached early adulthood, their rite of passage was often memorialized through tribal tattoo art. These body art designs were added to and embellished throughout the individual's life. Each tattoo was unique to that individual. Major life accomplishments, mastery of a set of vocational skills, or the achievement of a particular rank or status were commemorated through tribal tattoo art. A person's attributes as a good marriage partner might become part of their body art, noting they were

fertile, devoted, reliable, or prosperous. The tattoo designs of our ancestors became their living stories.

Tattoos were also used as talismans to provide protection from malicious forces, magic, or misfortune. Shamans and healers believed tattoos placed over specific body areas protected their tribesmen from physical aliments and debilitating diseases.

The natural world often was the source for the tribal designs. Bold spirals seen in the evening cloudbanks, wave patterns from the ocean, and long, flowing lines from twining flower tendrils make up the basic elements of tribal tattoos. Motifs and images were also added—stylized mammals, fish, birds, and even insects became talismans and totems.

Each cultural area of the world has its own style of representing tattoo elements in their body art. Polynesian tattoos, for example, incorporate large, bold triangle patterns that create repeated lines. Hawaiian work leans toward large black areas with finer unworked lines within the black fields. The Inuits favored elongated curved triangles with open scrolls and wave patterns. Long lines with tight turnbacks and ever-decreasing spirals appear in the Maori culture. The henna patterns of India contain the finest lined work, which incorporates natural elements such as flowers, stems, and leaves.

Each day, the ever-changing world of modern man becomes larger and more integrated. We have found ourselves within a world so mobile that there are few solid family

groups or clans and little or no traditional cultural histories to be passed on to us by our ancestors. It has become too easy to be lost in the crowd without individuality or identity.

The resurgence of tattoo art, especially in tribal designs, has once again given modern man a name and an individual identity. Just as our ancestors did, we use body art to define our accomplishments, aspirations, and spiritual ideas. The elements of tribal patterns reunite us with the natural world in contrast to our surroundings of technology, robotic production, and global transportation. It sets us apart from the unidentifiable masses.

As our ancestors did, we pull from our cultural setting for our designs. Today, in a melting pot society, we incorporate ideas and elements from many historic sources to create new, exciting body art. Bold triangle lines, spiked spirals, ragged curved lines, and stylized motifs make up today's favorite designs. Tattoos are no longer restricted to one location, one tribe, or one family. Today's tattoos are neo-tribal, reflecting our new worldwide family ties.

About the Patterns

In this book, you will find blackwork patterns that incorporate large, solid black areas with fine line accents; motif ideas (including totems and talismans); free-form designs that rely on long, curved line work to give an open but tangled feeling; and henna designs with their fine, delicate line work.

Also included are repeating elements often found in the modern neo-tribal tattoo. Traditionally, each person's tattoos were meant to be unique to that one person. These elements can be used to accent large patterns or to create your own pattern. Any of these elements can be mixed to tell your story or declare your individuality.

As you begin the process of creating and discovering your own personal tattoo designs, you might want to consider what attributes you wish to express in your body art. The list below includes common ideas, attributes, and spiritual assets.

Common Themes represented by tattoos

- Abundance/Affluence
- Adventure/Quests of the Soul
- Affection/Devotion/Passion
- Blessings/Worship
- Charm/Amulet/Fetish/Talisman
- Courage/Bravery/Valor
- Dedication/Faithfulness
- Descendants
- Determination/Conviction/Resolve
- Dominance/Authority
- Emancipation/Liberation
- Endurance
- Energy/Vigor/Dynamic Spirit
- Enshrine/Honor/Consecrate/Reverence
- Family/Lineage/Clan/Tribe
- Fertility
- Fighting Spirit/Crusade/Life Struggles
- Friendship/Alliances/Coalitions
- Greatness/Stature/Majesty
- Growth/Advancements/Evolution/Progress
- Happiness/Contentment
- Healing

- Independence/Self-Determination/ Self-Reliance
- Influence/Dominance/Driving Force
- Intuition/Instinct/Insights
- Long Life/Lasting/Permanent
- Love/Cherish/Idolize
- Magic/Sorcery/Witchcraft/Wizardry
- Negative Energy/Contradictory/Opposing
- Patronage/Guidance/Armor/Control
- Perspective/Outlook/Viewpoint
- Positive Energy/Self-Assured/Decisive/Dogma
- Prosperity/Fortune/Wealth
- Protection/Armament/Defense/Shield
- Purity/Innocence/Piety/Virtue
- Rebellion/Mutiny/Revolution/Insurgence
- Reputation/Prestige/Rank
- Sensuality/Sexuality
- Spirit/Core/Soul
- Strength/Vigor/Intensity/Brawn
- Success/Achievements/Triumphs/Victories
- Talisman/Totem/Amulet
- Upheaval/Uprising/Revolt

Modifying and Creating Your Own Designs

Tattoos have always been used to emphasize outstanding parts of one's personality, special events, membership within a particular clan, social status, or hard-earned achievements. Because each event or quality is unique to that individual, that person's tattoos become unique and unlike any other person's tattoo pattern.

Even though each person's tattoo pattern is different, most tribal-style tattoos depend on repeated patterns based on the triangle, circle, spiral, or free-form lines. To these basic units, a focus image can be added, such as a coiled snake, a hawk's face, a feather, or any other image that speaks about the person's life. Therefore, what makes any tattoo pattern unique to an individual is not only the actual elements used in the design, but also the way they are combined.

The tattoo designs included in this volume can be used as they are presented. However, with a little work, a pencil, a few sheets of graph paper, and the design elements in this book, you can create your own tattoos unique to you and your life.

The Basic Design Shapes

Tribal elements often fall into a few basic shape categories: triangle, circle, spiral, or line. These elements can be used alone for small tattoos around the wrist, ankle, or upper thigh, or they can be combined to create large tattoos for the shoulder, chest, or back. By mixing different shapes within your tattoo, you add interest and tension as the eye moves from one element area into the next.

Triangle designs are the most common pattern found in tribal tattoos and are worked over a square grid. **Figure 1.1** has been plotted within a 4x4 grid. Once the triangle outlines have been established, you can fill the entire triangle area with black, use a graduated dot pattern fill, or add small interior design lines.

The concentric circle grid can be used to create patterns that bend along an arc. As you work with the concentric circle grid, you can draw different patterns using the expanding circles and have all of those patterns united because they come from the center point of the circle. In **Figure 1.2** (page 12), the radius lines from the center point are also used to create the shaft lines of the arrow points.

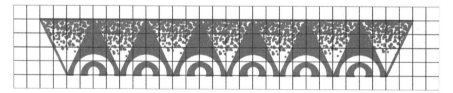

Figure 1.1. A simple square grid is used to create a repeating triangle design. You can vary the height and width of the triangle by changing the number of squares between the corner points.

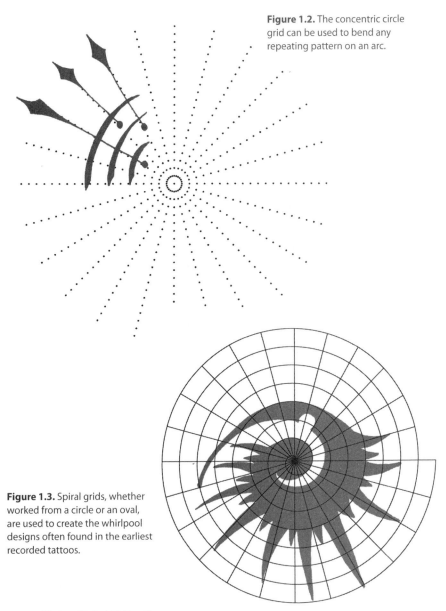

Figure 1.2. The concentric circle grid can be used to bend any repeating pattern on an arc.

Figure 1.3. Spiral grids, whether worked from a circle or an oval, are used to create the whirlpool designs often found in the earliest recorded tattoos.

Dust Devil

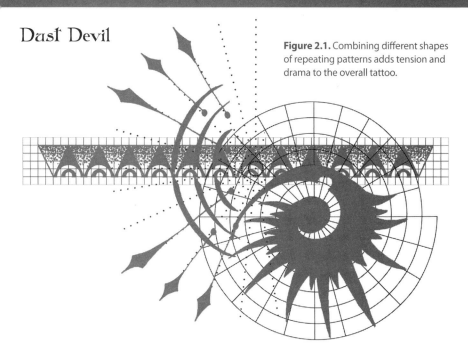

Figure 2.1. Combining different shapes of repeating patterns adds tension and drama to the overall tattoo.

Spirals work from a center point and use a segmented line that continually turns outward. In **Figure 1.3**, the spiral begins with a large dot and then flows out from the center in a thick-then-thin comma stroke. Spikes were added using the radius lines of the grid.

Three basic element shapes—triangle, circle, and spiral—have been combined in **Figure 2.1** to create a new and unique tattoo. Working on printed copies of the grid papers on pages 144 to 150, a simple outline pattern was drawn for each unit of this larger design. After each unit or element has been penciled onto the paper grids, you can cut out just the design section of your grid pattern, and then lay the different grid paper elements together and adjust them until you have the balance and flow within the design that appeals to you. Use clear tape to secure the grid paper pieces together in your final arrangement. In **Figure 2.2** (page 14), the arrow point line element was used twice to add more weight to the bottom area.

Lay a sheet of tracing or vellum paper over your roughly drawn draft and make a new tracing of the completed design, copying only the outline for each element. Next, shade the individual elements. Tribal tattoos can be worked in solid black (where the element itself is filled with black) or in blackwork (where the element is left skin-colored and the background is black) to give a strong, bold effect. Fine dot patterns can be used to fill an area and are excellent for implying water movement, air currents, or celestial space. Fine-line outlines are common in henna-style designs.

In **Figure 2.2**, a variety of texture and fill patterns were used. The dot pattern in the triangle element gives an open-air space for the motion of the dust devil whirlpool. The whirlpool spiral is the most important element, so it was worked in a solid black fill. The fine-line work of the arrow points implies the direction or path of the dust devil's movement.

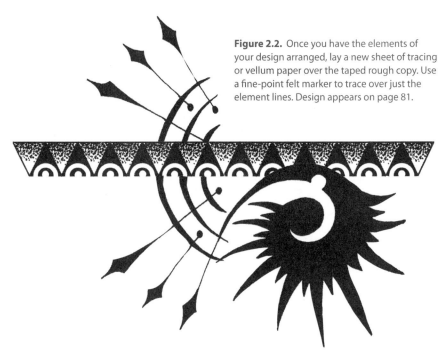

Figure 2.2. Once you have the elements of your design arranged, lay a new sheet of tracing or vellum paper over the taped rough copy. Use a fine-point felt marker to trace over just the element lines. Design appears on page 81.

Sample Grid Pattern Layouts

Because tattoos can be anything from a simple repeated triangle or line design to very complex large designs worked from multiple patterns, grid work will help guide you through the process of creating more complex ideas. Below are a few grid layout ideas plus pattern work samples to get you started. You can find full-page copies of the grids in the section on page 144 and full-page copies of the completed patterns in the pattern section.

Tail Winds

Figure 3.1. This armband or anklet grid is worked with one central triangle dot pattern grid and two concentric circles. The circle grid has been cut into half circles with one large grid below the triangle line and a smaller half circle above.

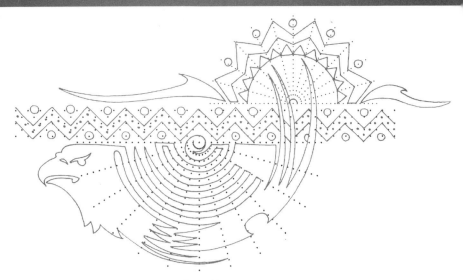

Figure 3.2. The zigzag pattern is one of the oldest historic tattoo repeats. Here, in combination with a dot pattern, it represents air currents. The air current theme leads to the use of an open sun above the triangle line with free-form solar flares. The lower, larger concentric circle grid became a stylized falcon.

Figure 3.3. Working with the outer rings of the concentric circle grid, I pulled the tail feathers of the falcon smoothly through the triangle line and into the upper half circle. Design appears on page 82.

Summer Winds

Figure 4.1. This armband grid uses an oval spiral grid for the main element design. The dot pattern triangle grid is used for the main centerline with a small half-concentric-circle grid for the lower area of work.

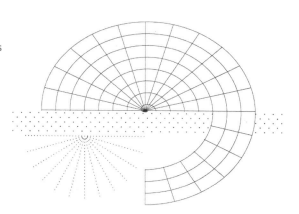

Figure 4.2. An open sun was drawn in the lower circle grid. The radius lines on either side have a dot pattern to imply sunrays. The upper half of the sun appears in the center of the spiral. A halo of triangles creates an aurora with a spike line of blackwork in the outer bands of the spiral.

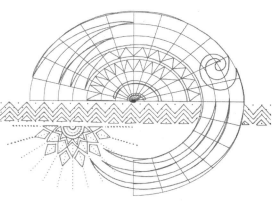

Figure 4.3. The inked design shows the open line work in the triangle element that adds the feeling of air, or space, to the tattoo. Large design appears on page 82.

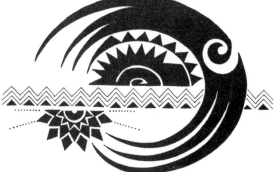

Henna Anklet

Figure 5.1. Triangle lines can be twisted and warped to add movement to your design. This grid for an armband or foot piece uses two triangle dot grids curved around an oval grid. By bending a triangle grid, you can create proportionally graduated elements.

Figure 5.2. Flower petals of a henna-style pattern are penciled into place. To keep this design organic, the triangle work uses curved lines, small dots, and scrolls. The leaves fill the space between the triangle grid areas and the oval.

Figure 5.3. Fine parallel lines fill the leaves and small triangles of the left triangle grid. A random dot pattern adds shading to the petals. This finished tattoo has a nice mixture of solid black areas, textures, and fine-line details. Large design appears on page 123.

War Path

Figure 6.1. Large tattoos for the chest, shoulder, or back have room for multiple grids. This layout uses three bent triangle grids, arranged to add an outer spiral. The focus of the tattoo will lie inside the spiral circle grid with small element work of either free-form line or triangle designs in the square grid area.

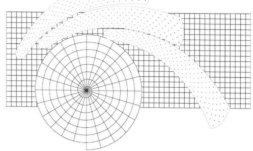

Figure 6.2. A blackwork spiral leads into a simple repeated triangle. The simple triangle element was used in the three bent-triangle areas. To add darkness and strength, a free-form line was added. A line of simple triangle elements finishes this pencil drawing and was worked along the diagonal of the square grid.

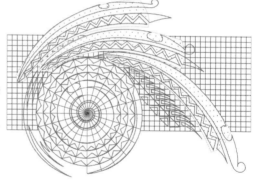

Figure 6.3. This finished tattoo has strength because of the solid blackwork throughout the individual elements. The repeating of the simple triangle gives the feeling of footprints or walking stones. Everything in this design leads the eye to the central heavy spiral. Large design appears on page 83.

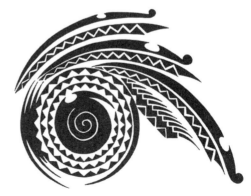

Rain Dance

Figure 7.1. The addition of the three straight square grid areas to the curves of the spiral oval grid and bent-triangle grid adds conflict to this layout. This is an excellent layout for creating multiple changing triangles or free-form line elements.

Figure 7.2. A spiral line blends into a spike line along the outer rings of the oval. The spiral was carried into the bent-triangle grid by marking open areas in this curved unit. Notice that the bent-triangle grid was not used to establish individual triangles; instead, the outline of the bend was used to curve the open work area. A series of triangle lines were penciled into the square grid area to add multiple changing elements.

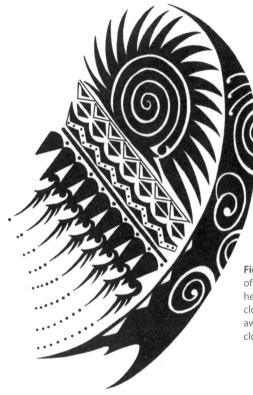

Figure 7.3. This tattoo captures one moment of time with a partial sun moving across the heavens surrounded by a blackwork storm cloud. The rain flows with a diagonal motion away from the sun and with the curve of the cloud. Large design appears on page 29.

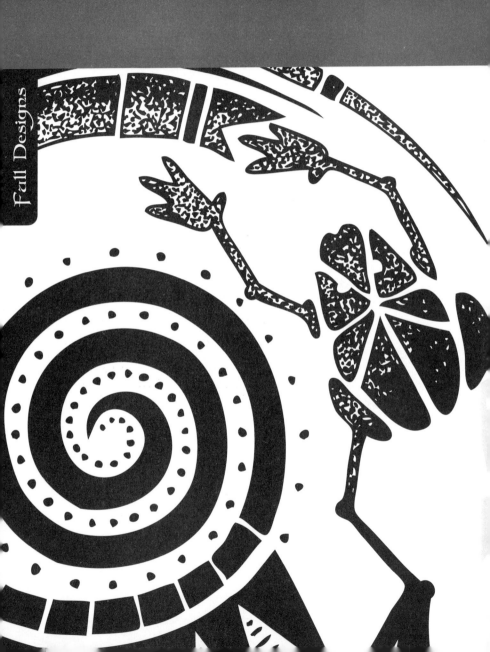

Full Designs

The designs in this section are complete designs and can be used as is. However, I encourage you to modify any of the patterns to make them more your own. You'll find bold, dark blackwork patterns, neo-tribal designs that combine themes and images with classic lines and triangular patterns, newer free-form designs with flowing lines, and fine-line henna designs.

Blackwork

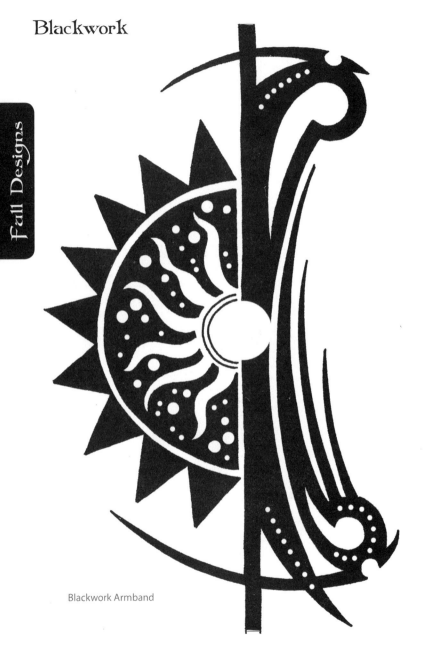

Blackwork Armband

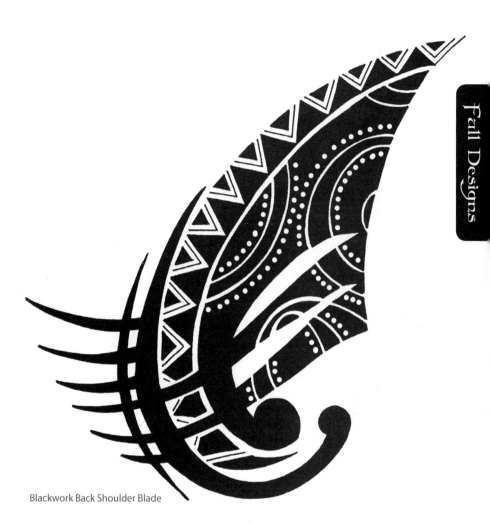

Blackwork Back Shoulder Blade

Blackwork

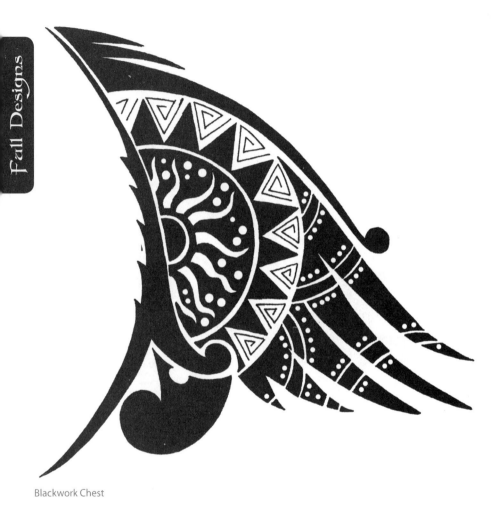

Blackwork Chest

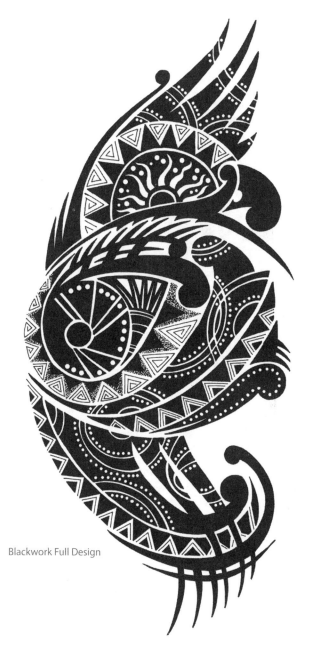

Blackwork Full Design

Blackwork

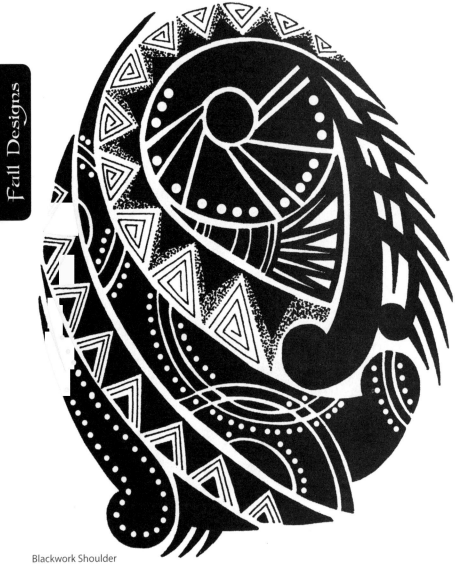

Blackwork Shoulder

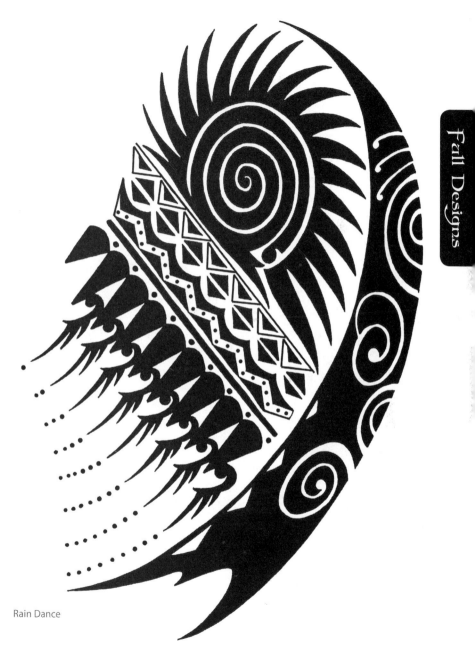

Rain Dance

Neo~Tribal

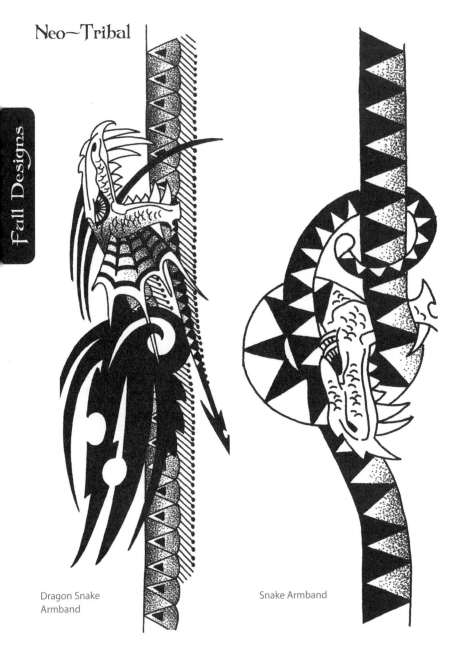

Dragon Snake
Armband

Snake Armband

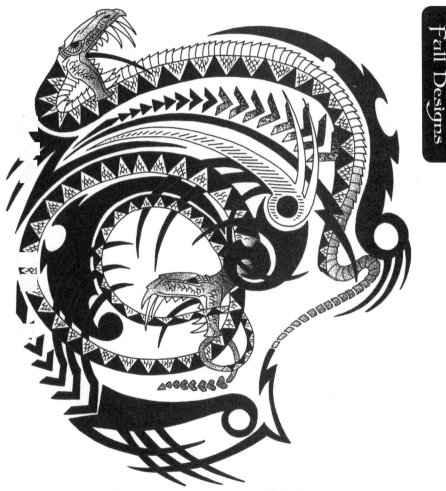

Full Back Snake

Neo~Tribal

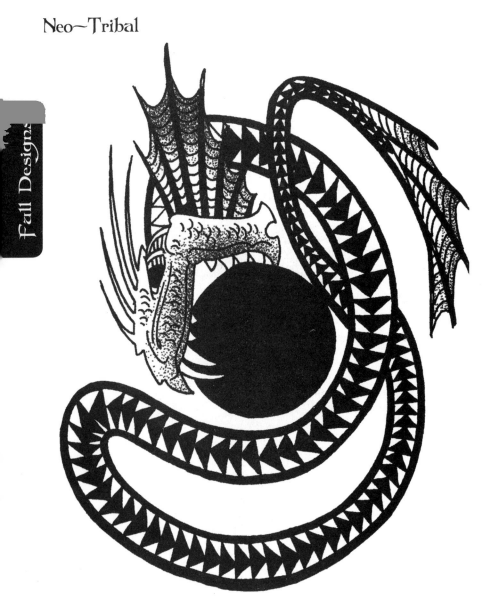

Dragon Snake Shoulder

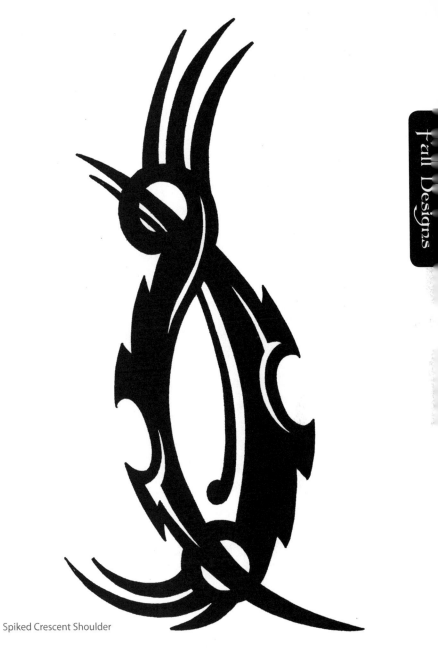

Spiked Crescent Shoulder

Neo~Tribal

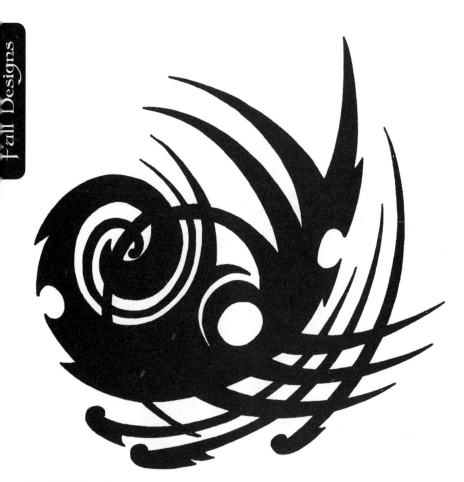

Spiked Spiral Shoulder

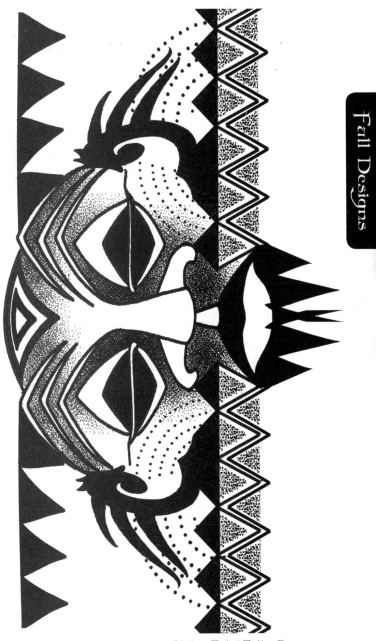

Ancestor

Neo~Tribal

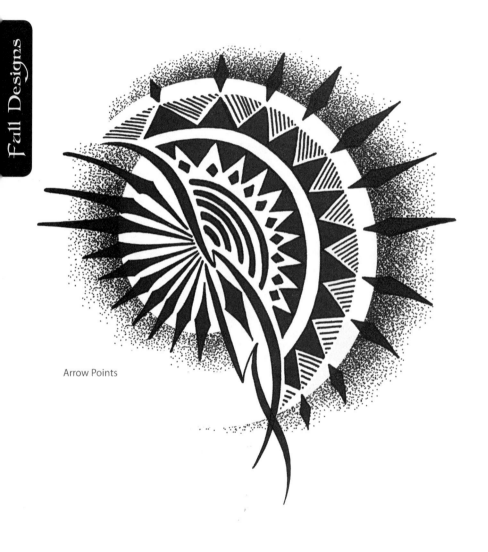

Arrow Points

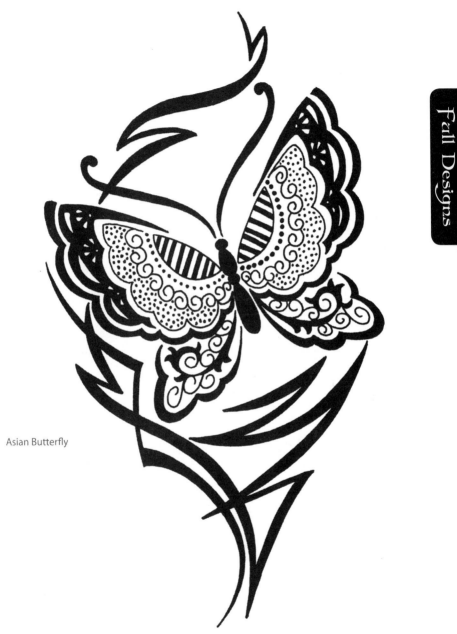

Asian Butterfly

Neo~Tribal

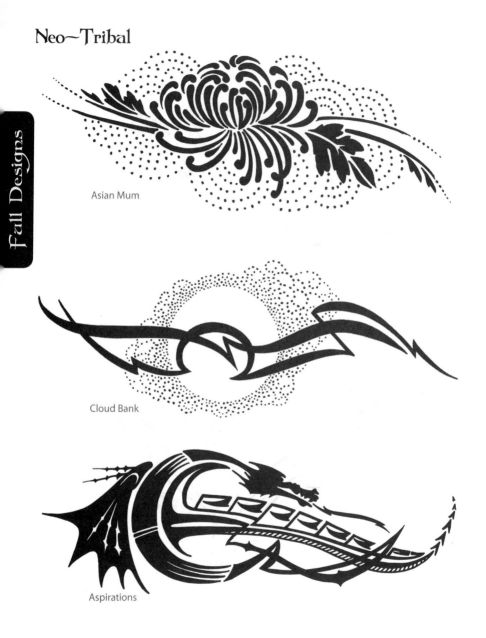

Asian Mum

Cloud Bank

Aspirations

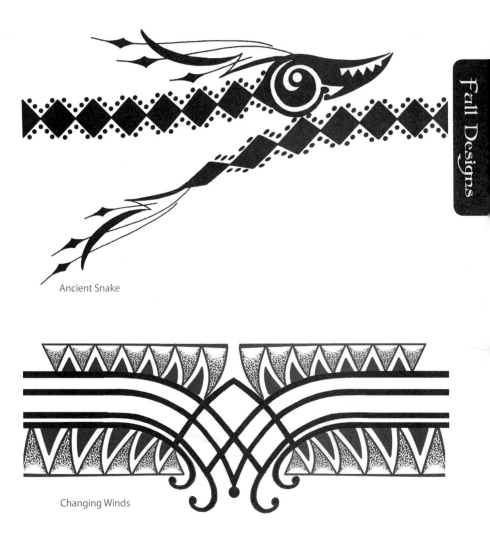

Ancient Snake

Changing Winds

Neo~Tribal

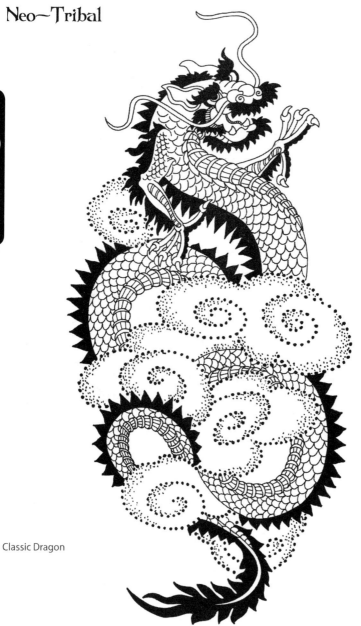

Classic Dragon

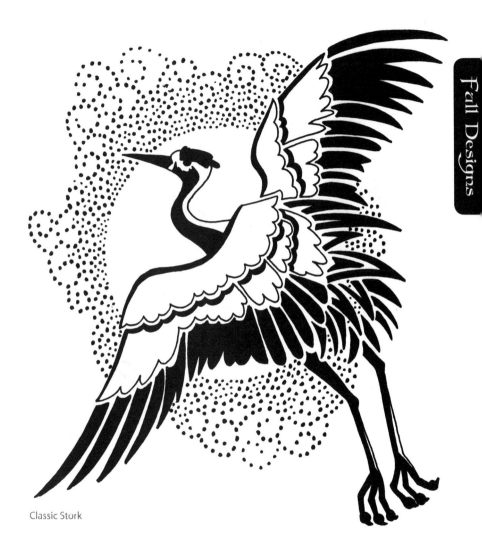

Classic Stork

Neo~Tribal

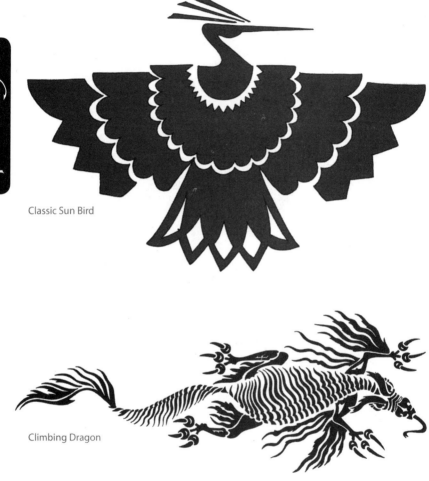

Classic Sun Bird

Climbing Dragon

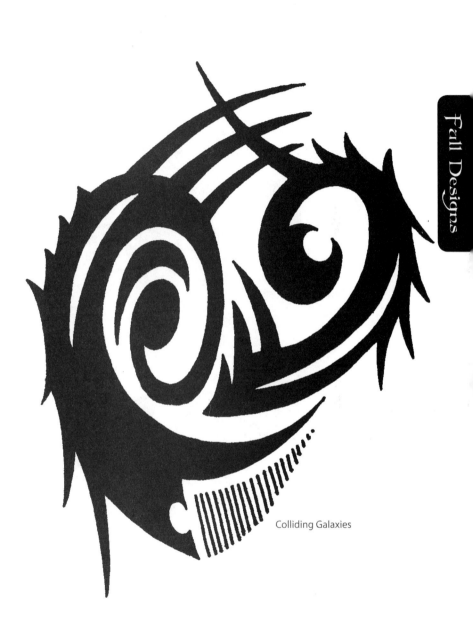

Colliding Galaxies

Neo~Tribal

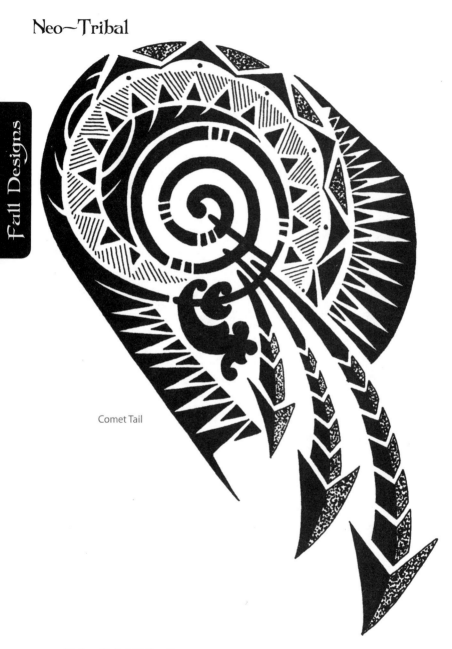

Comet Tail

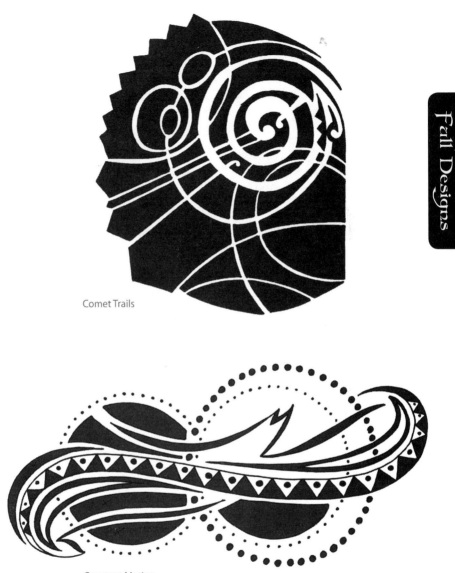

Comet Trails

Constant Motion

Neo~Tribal

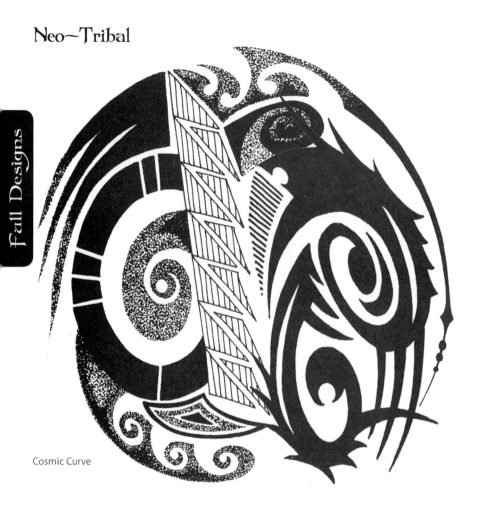

Cosmic Curve

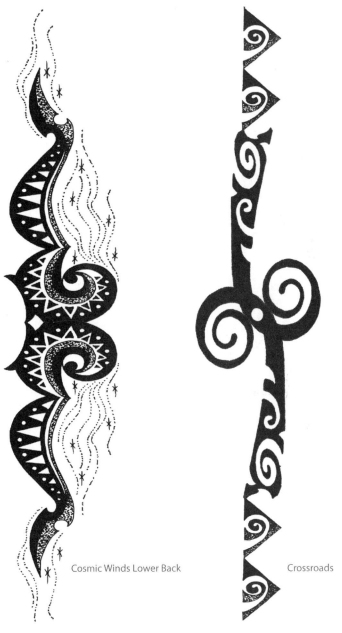

Cosmic Winds Lower Back

Crossroads

Modern Tribal Tattoo Designs 47

Neo~Tribal

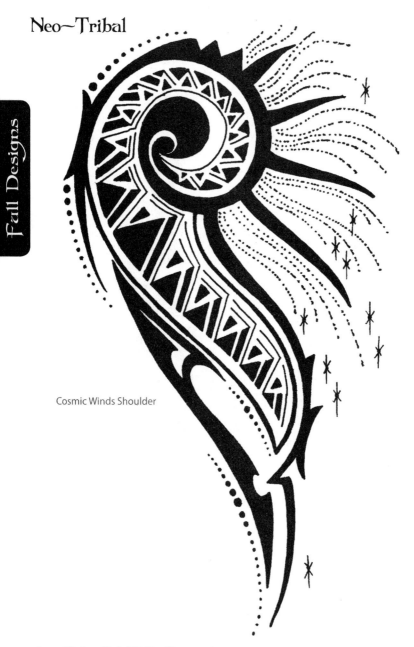

Cosmic Winds Shoulder

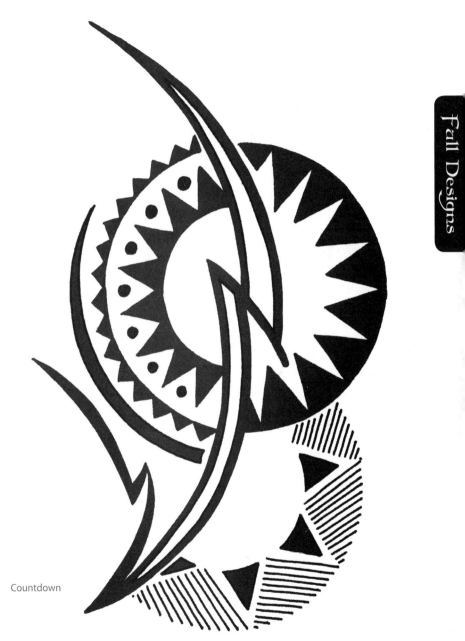

Countdown

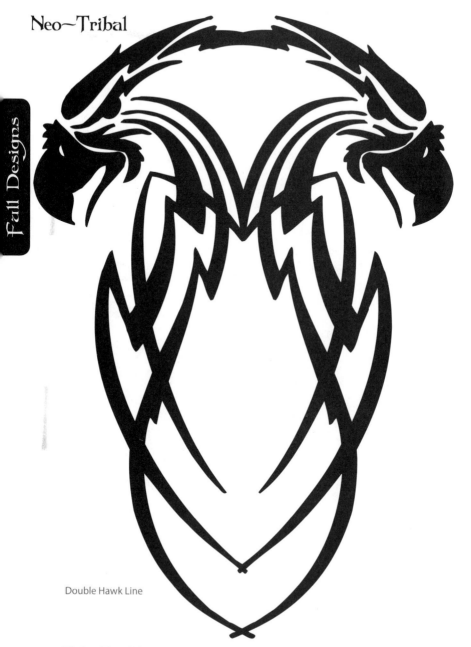

Double Hawk Line

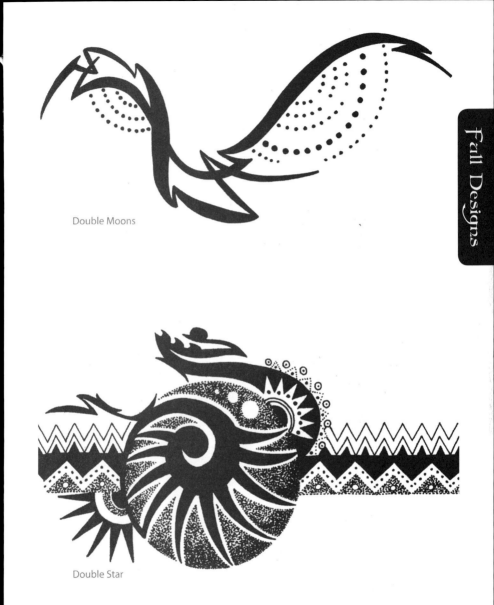

Double Moons

Double Star

Neo~Tribal

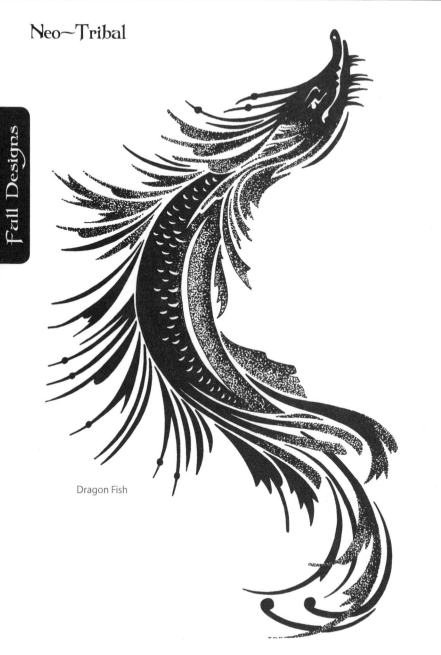

Dragon Fish

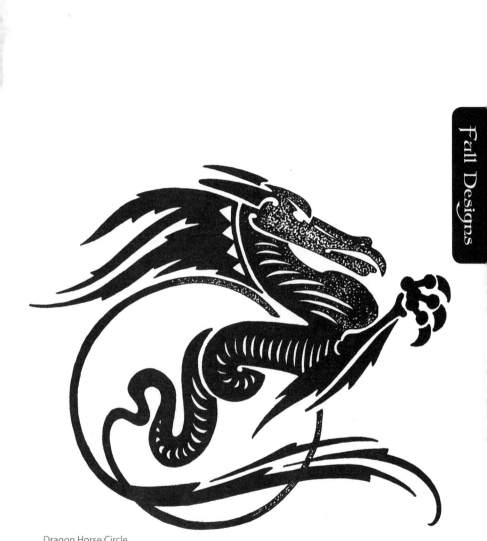

Dragon Horse Circle

Neo~Tribal

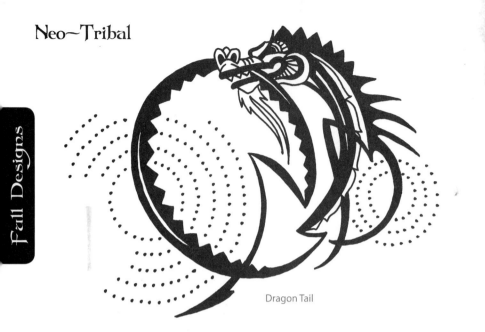

Dragon Tail

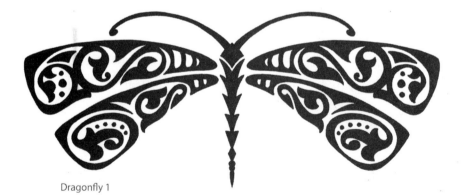

Dragonfly 1

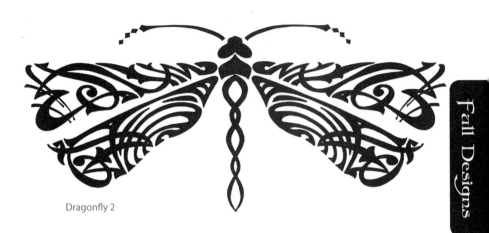

Dragonfly 2

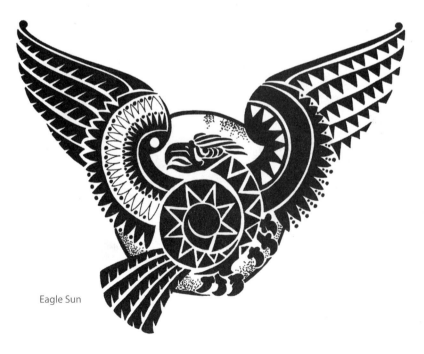

Eagle Sun

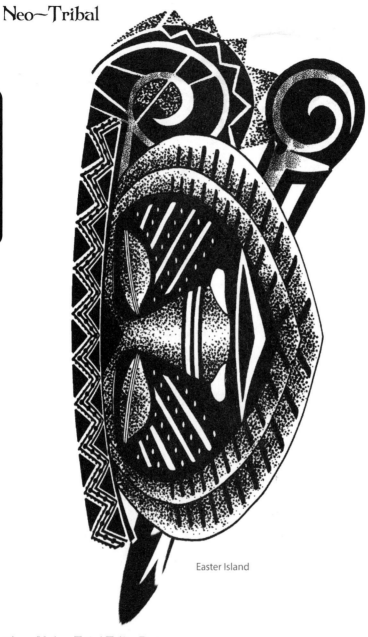

Easter Island

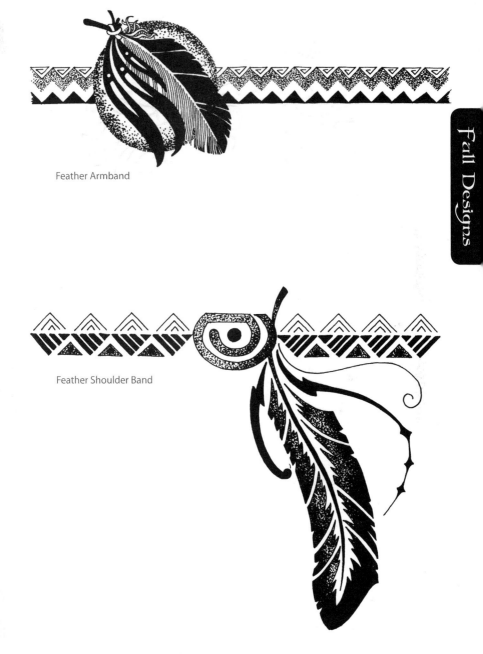

Feather Armband

Feather Shoulder Band

Fall Designs

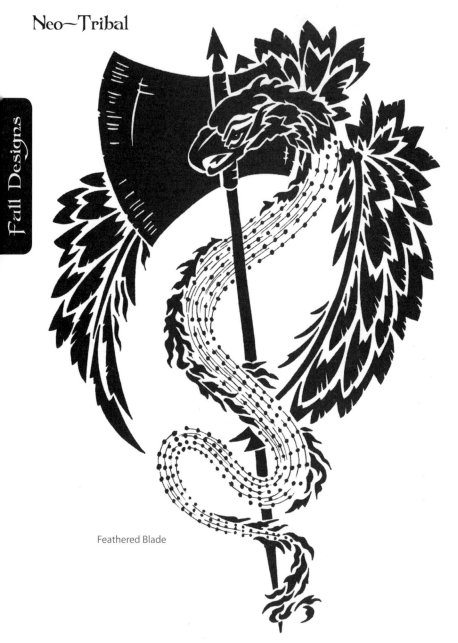

Feathered Blade

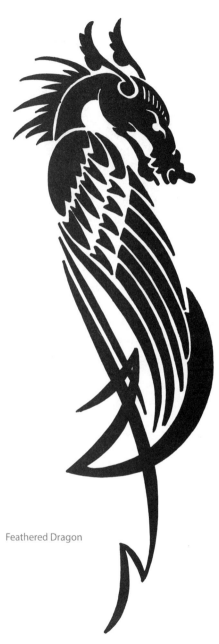

Feathered Dragon

Neo~Tribal

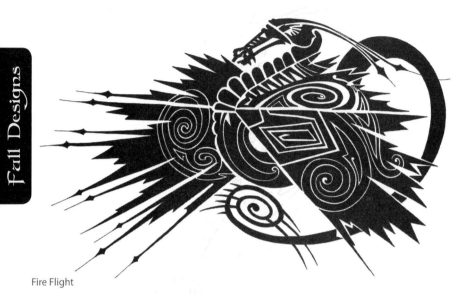

Fire Flight

Firm Directions

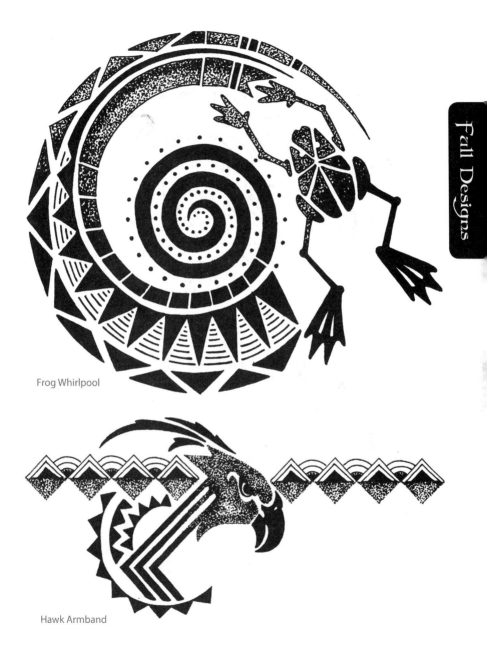

Frog Whirlpool

Hawk Armband

Neo~Tribal

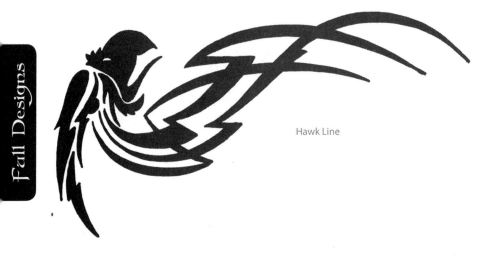

Hawk Line

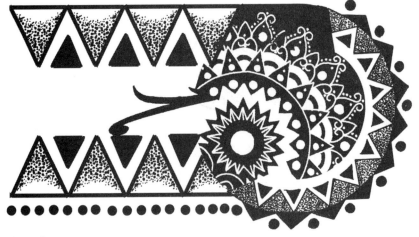

Henna Comet

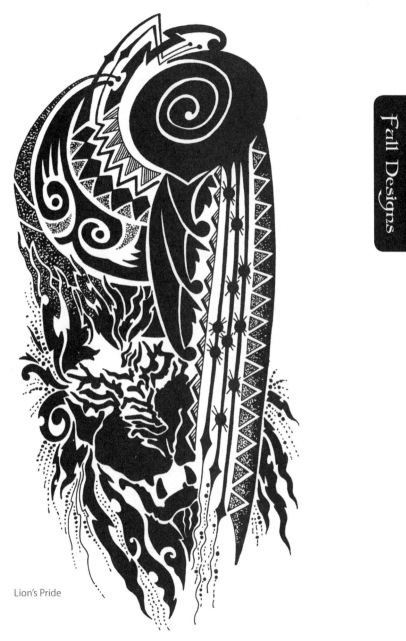

Lion's Pride

Neo~Tribal

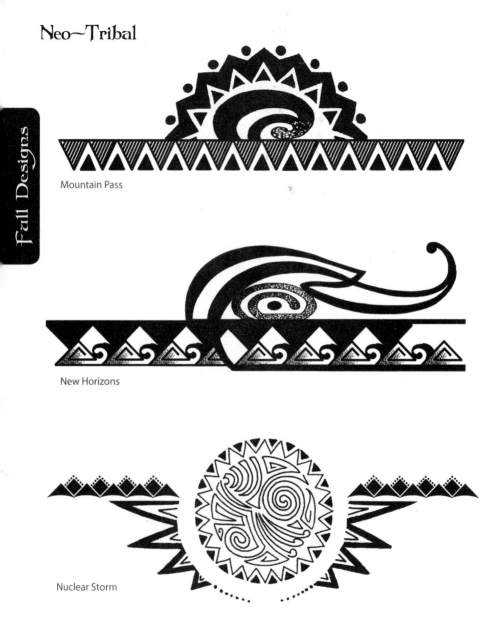

Mountain Pass

New Horizons

Nuclear Storm

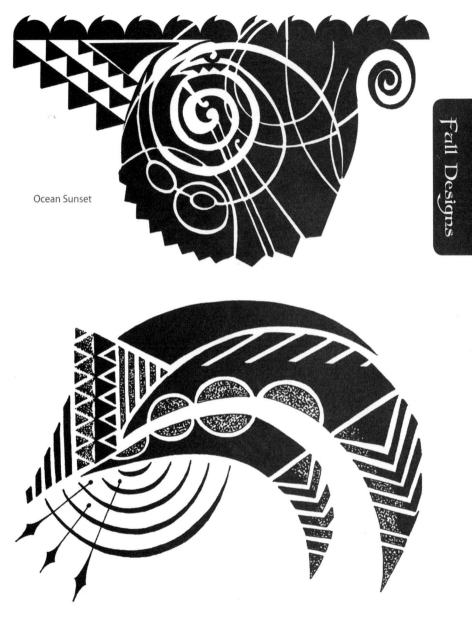

Ocean Sunset

Rippled Water

Modern Tribal Tattoo Designs 65

Neo~Tribal

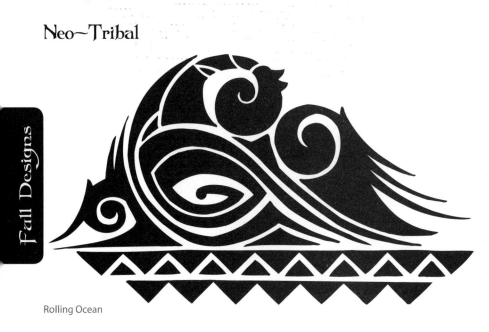

Rolling Ocean

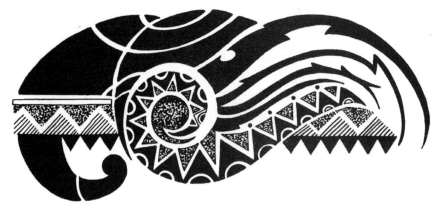

Rolling Swirls

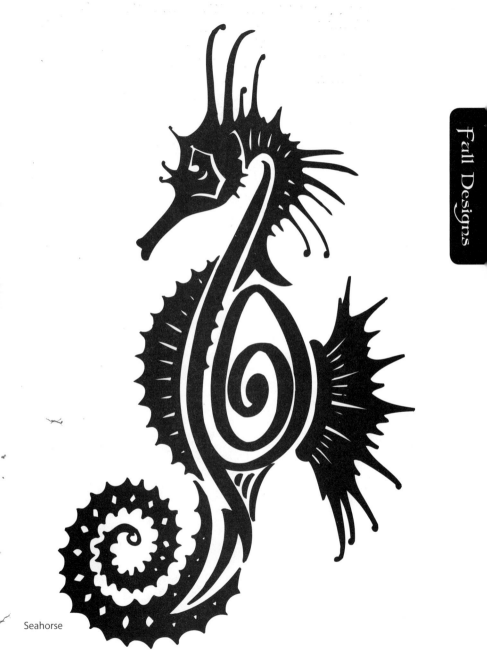

Seahorse

Neo~Tribal

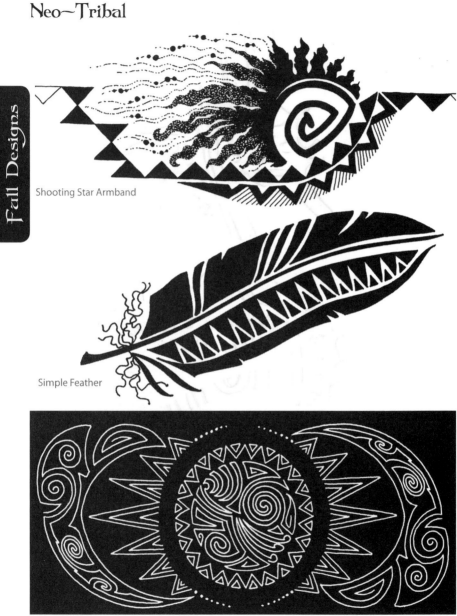

Shooting Star Armband

Simple Feather

Solar Storm

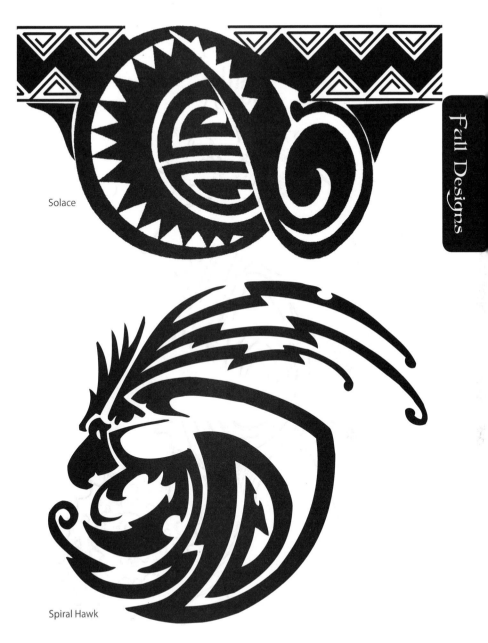

Solace

Spiral Hawk

Modern Tribal Tattoo Designs **69**

Neo~Tribal

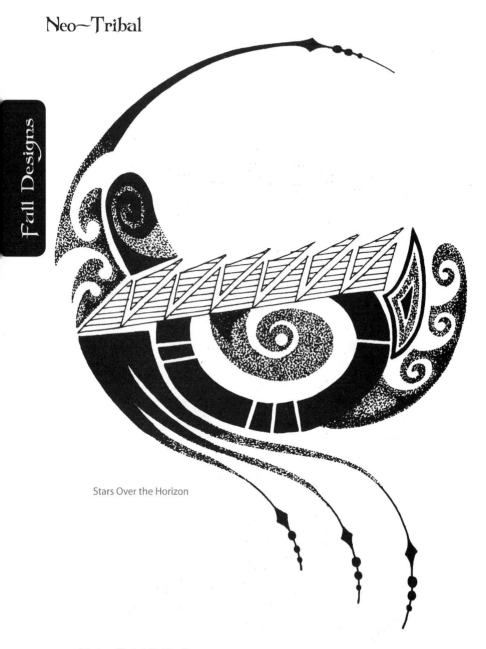

Stars Over the Horizon

Star Name Armband

Star Trails Armband

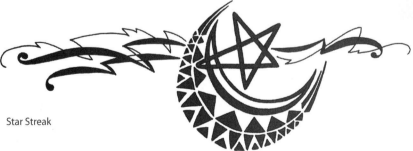

Star Streak

Neo~Tribal

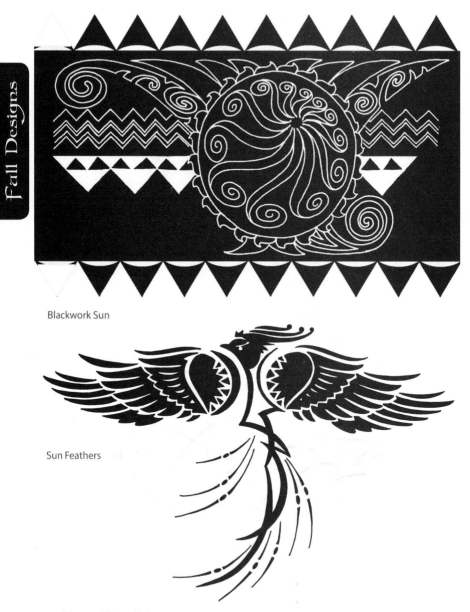

Blackwork Sun

Sun Feathers

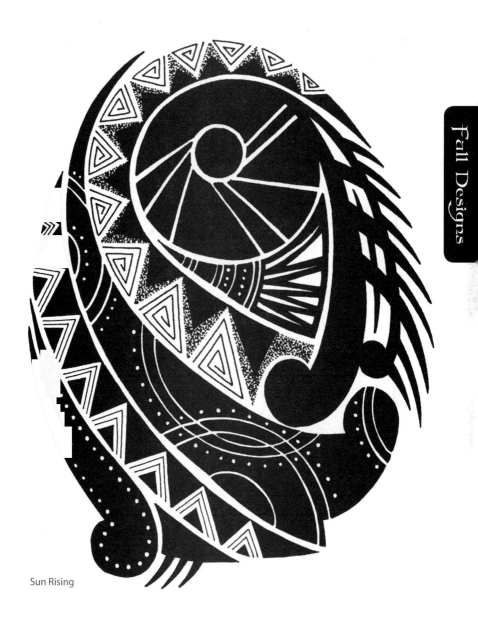

Sun Rising

Neo~Tribal

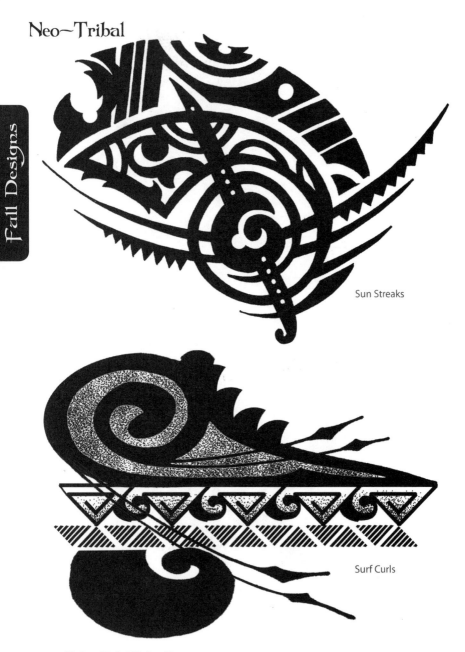

Sun Streaks

Surf Curls

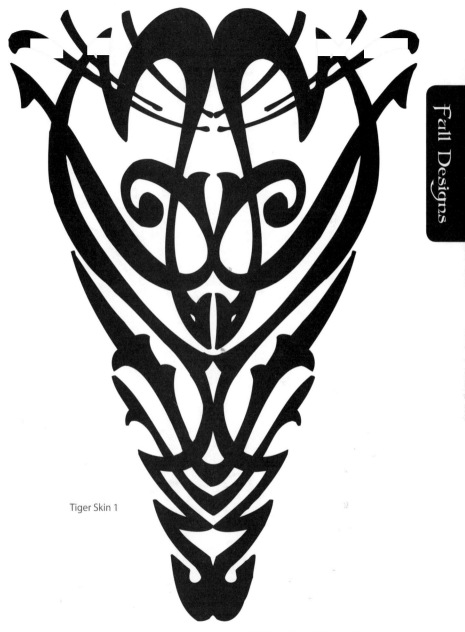

Tiger Skin 1

Neo~Tribal

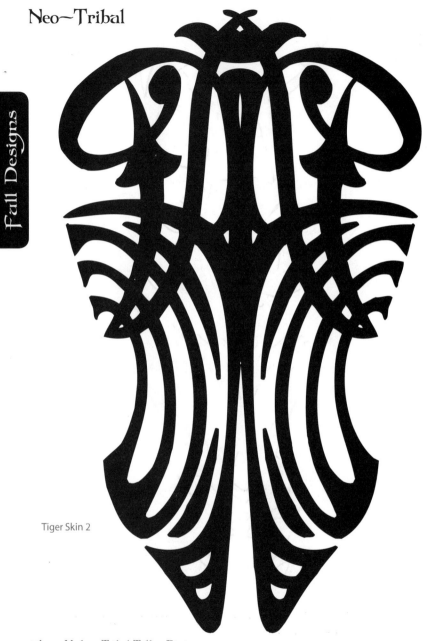

Tiger Skin 2

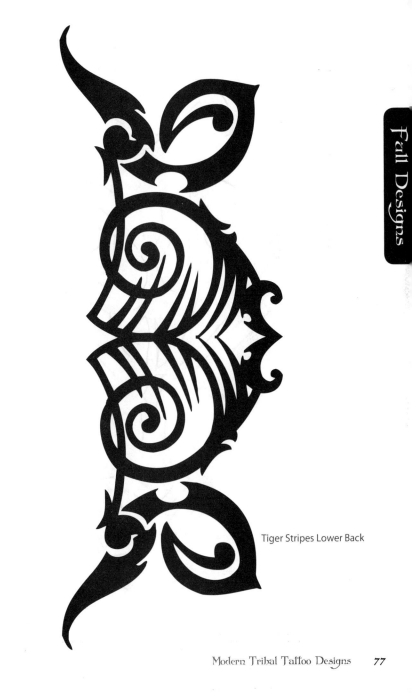

Tiger Stripes Lower Back

Neo~Tribal

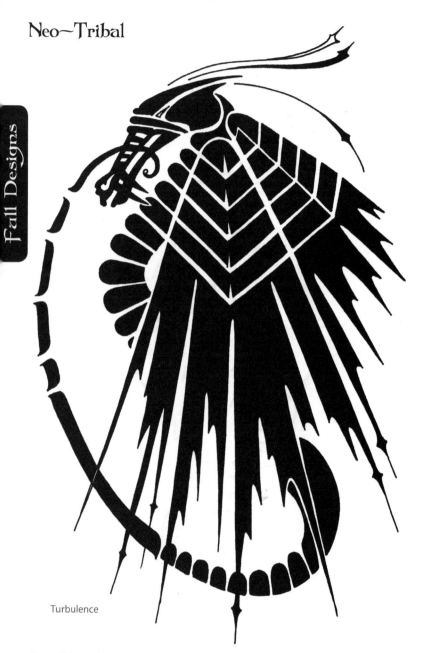

Turbulence

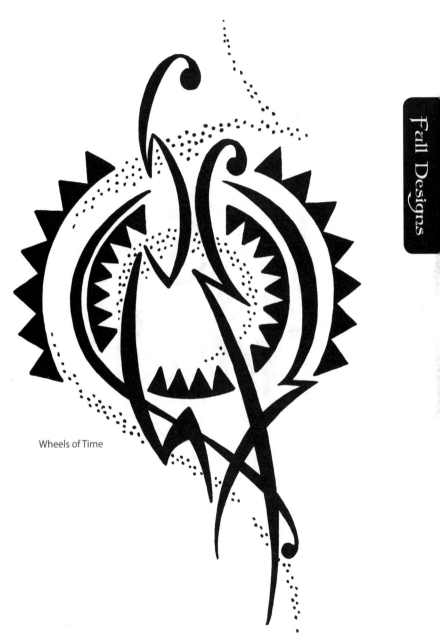

Wheels of Time

Neo~Tribal

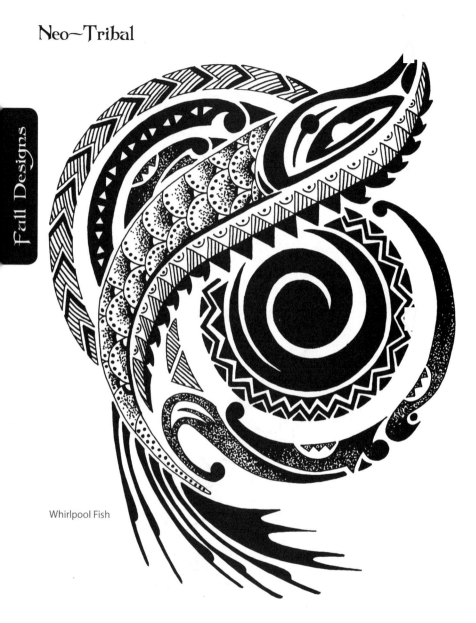

Whirlpool Fish

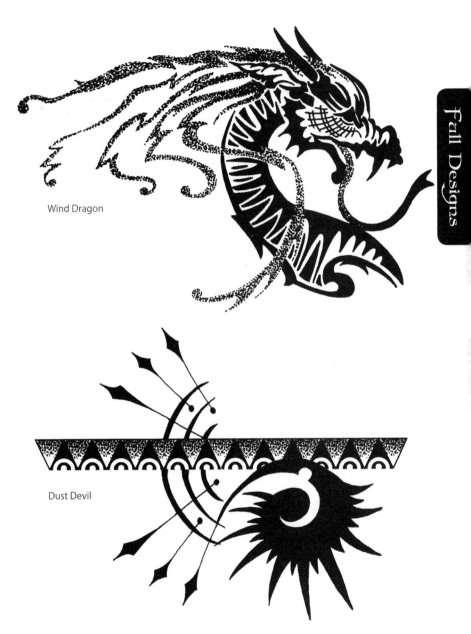

Wind Dragon

Dust Devil

Neo~Tribal

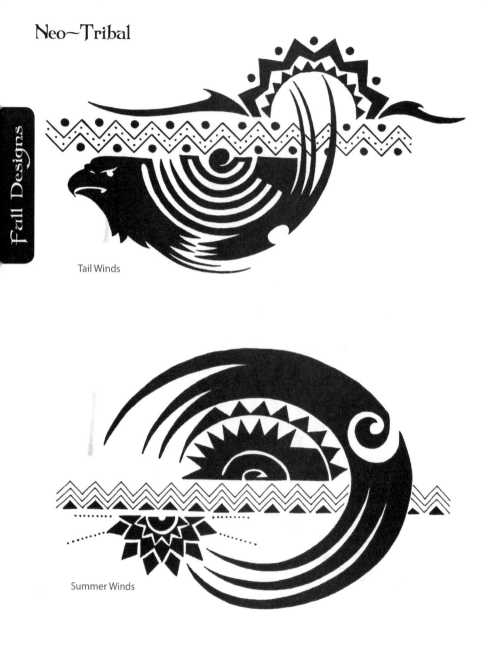

Tail Winds

Summer Winds

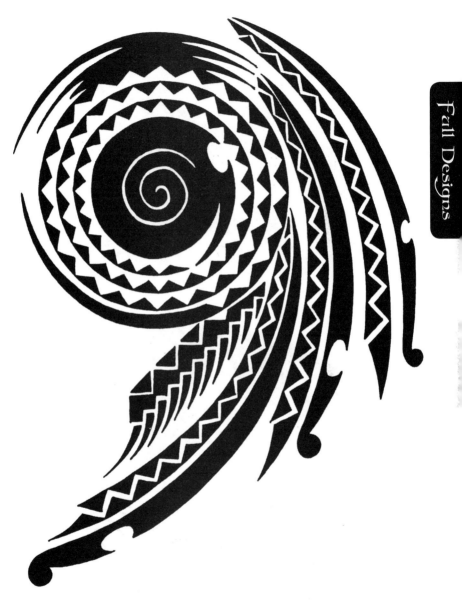

War Path

Free Form

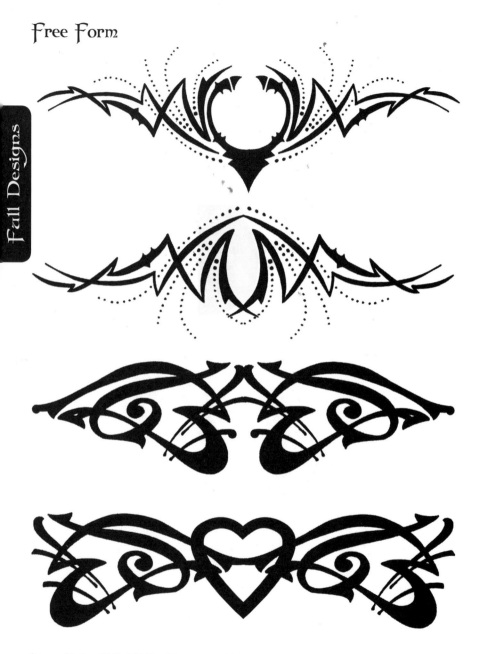

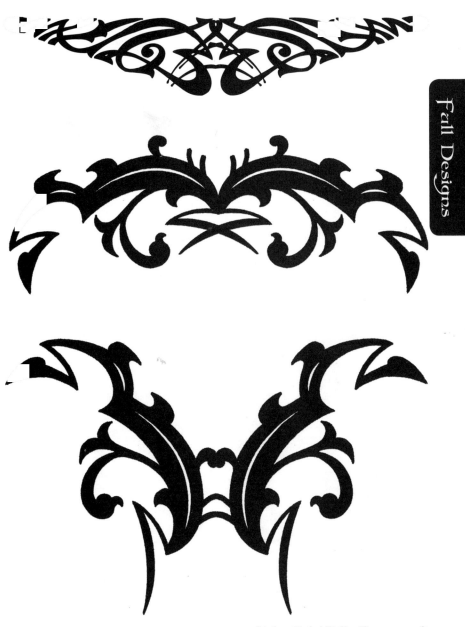

Free Form

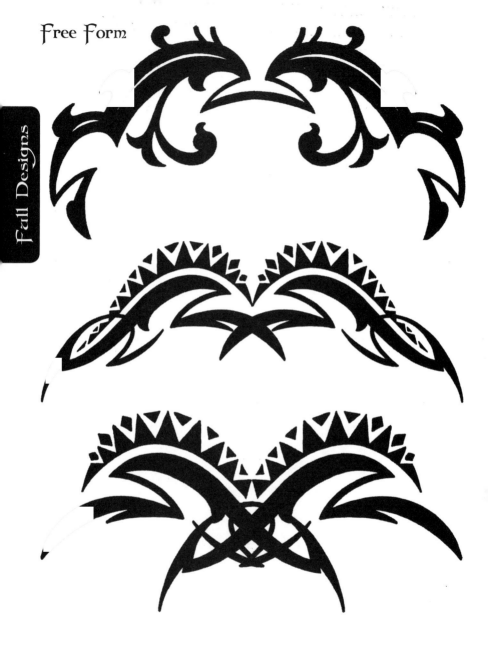

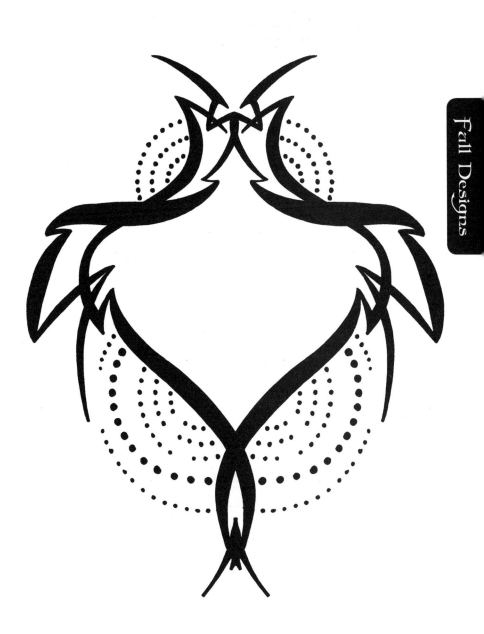

Free Form

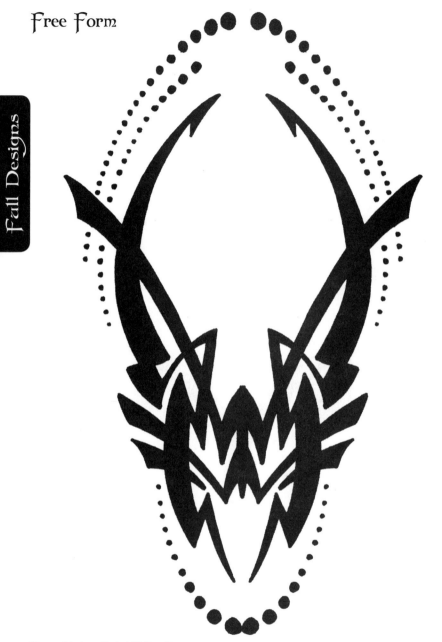

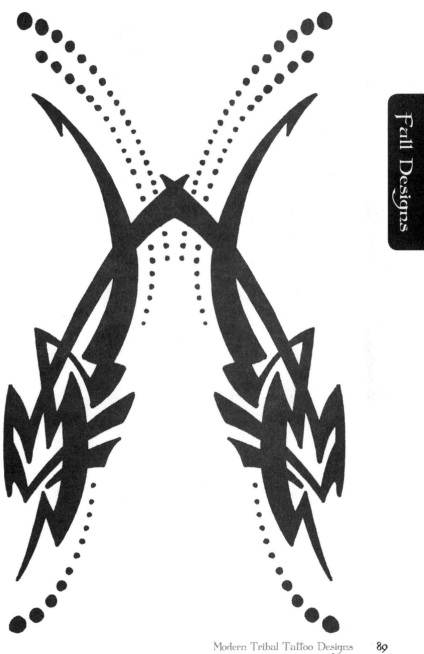

Free Form

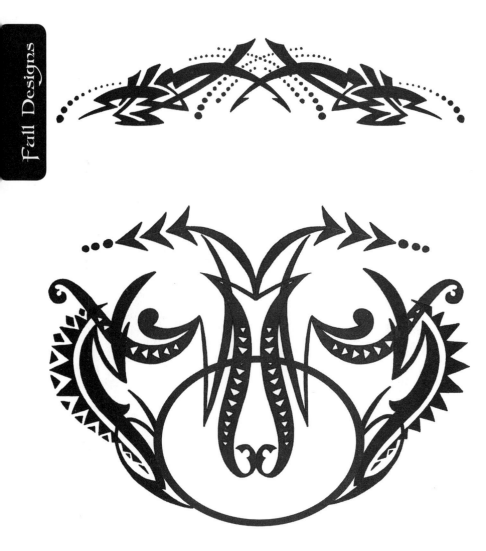

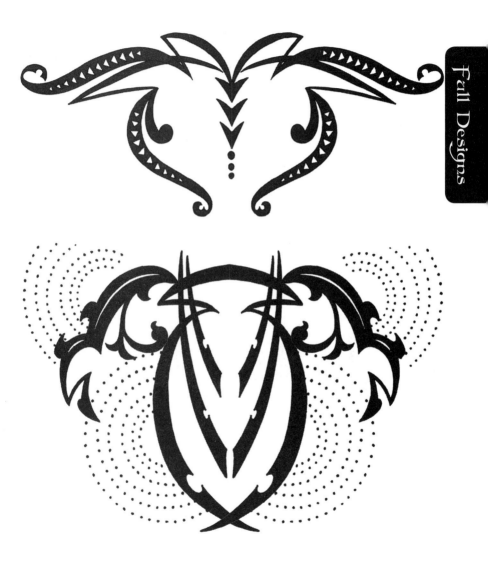

Free Form

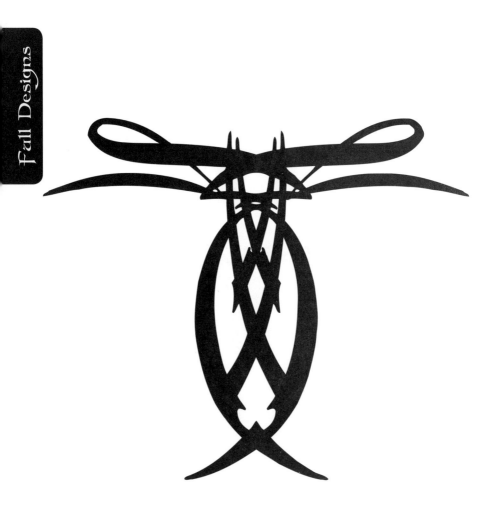

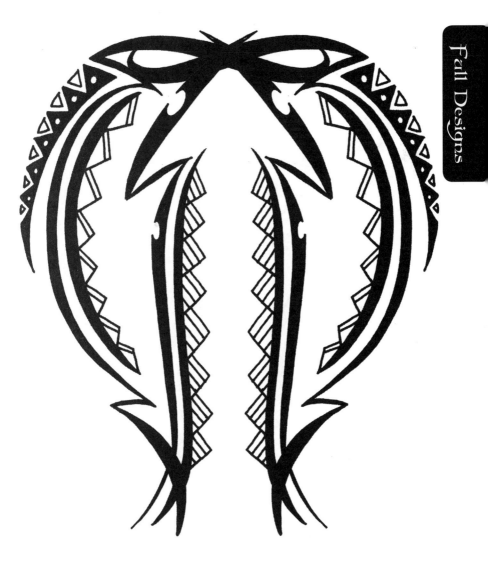

Free Form

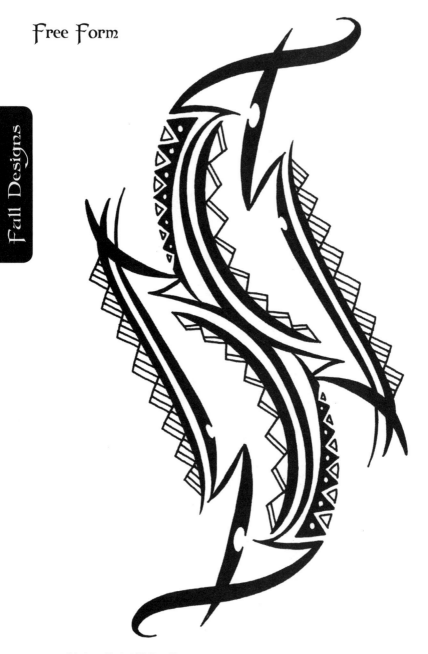

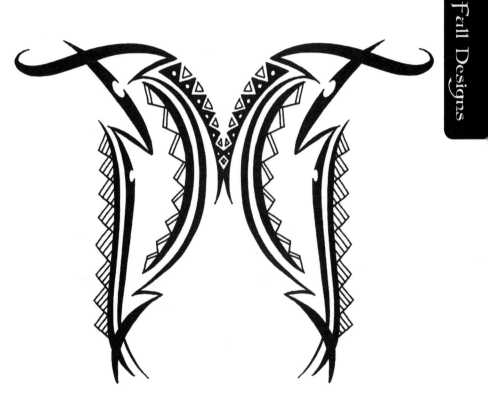

Free Form

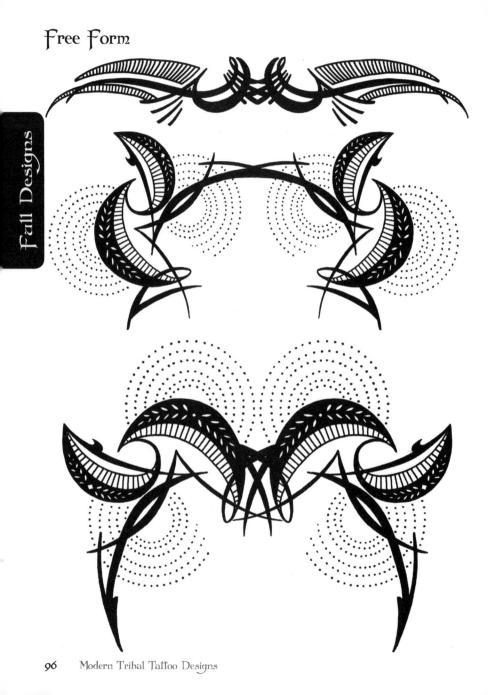

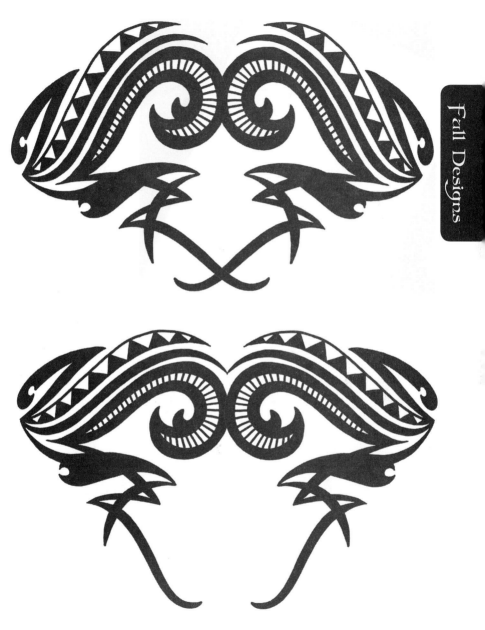

Free Form

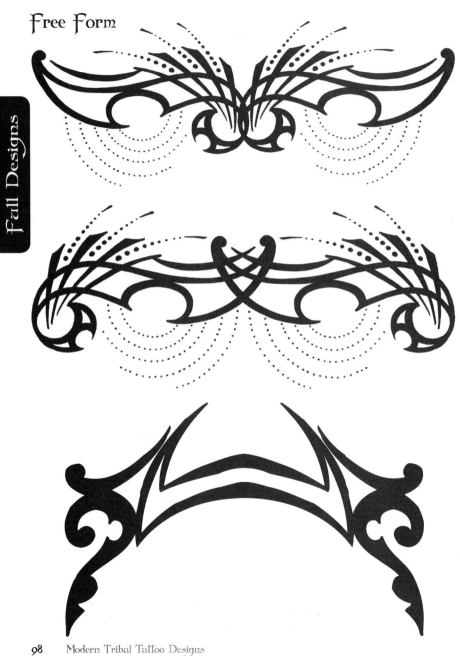

Free Form

Free Form

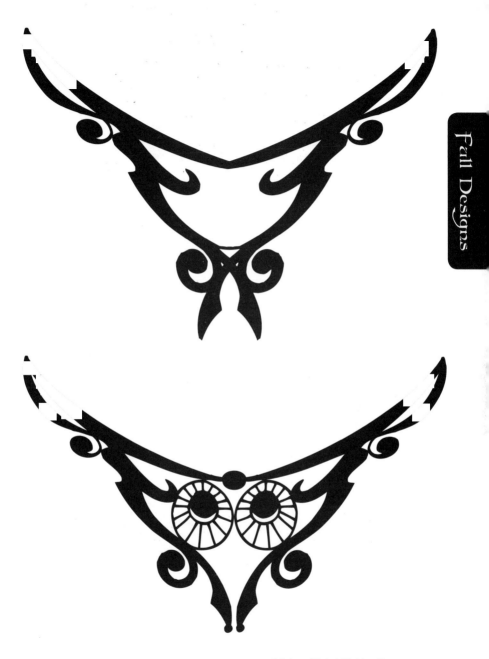

Free Form

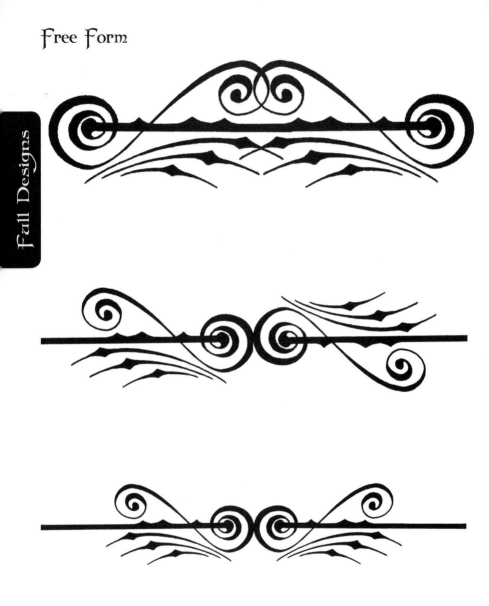

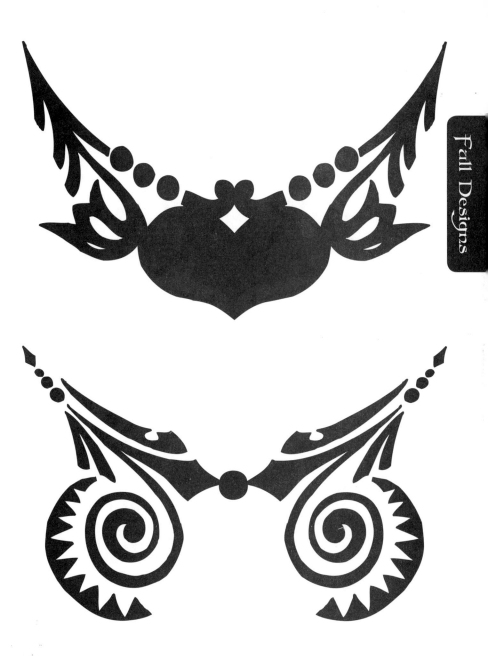

Free Form

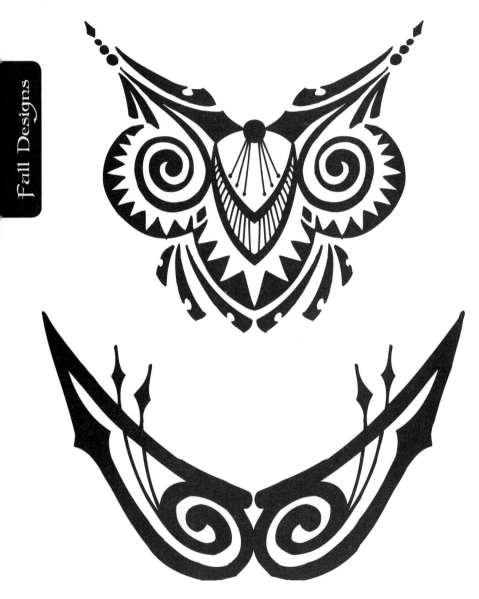

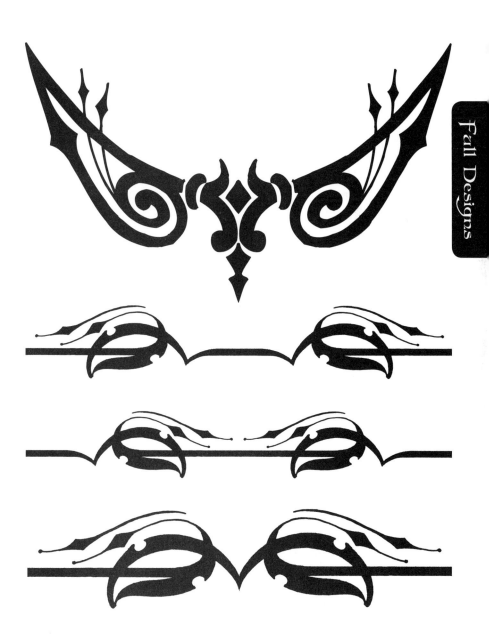

Free Form

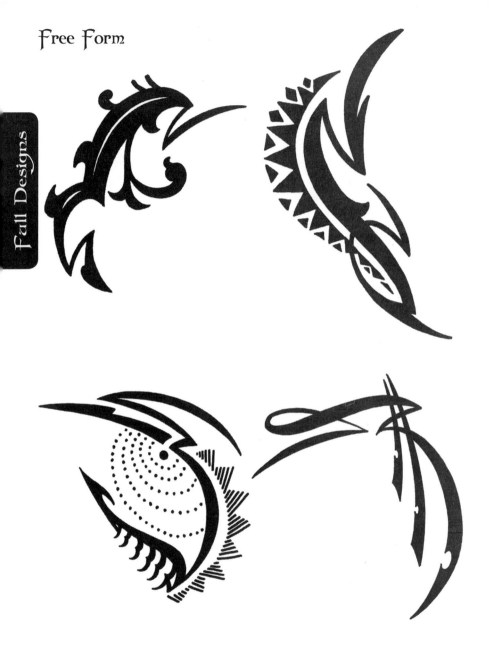

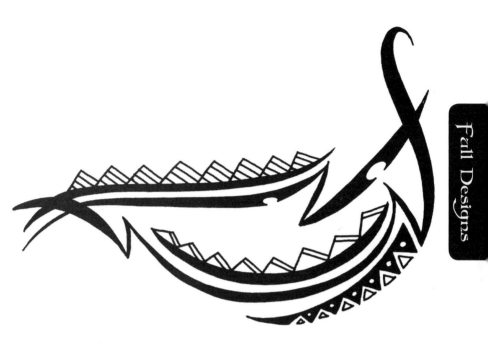

Free Form

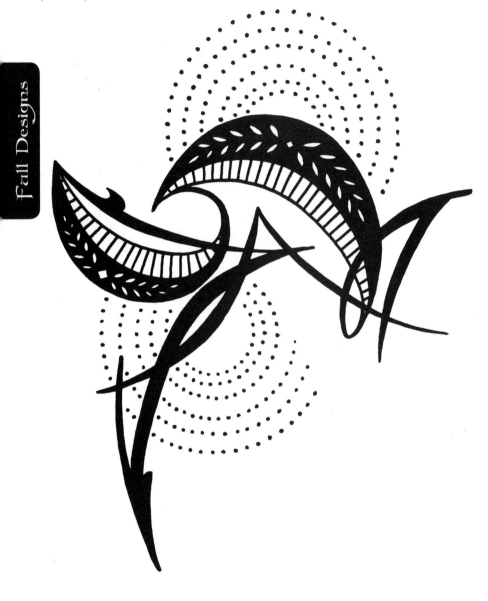

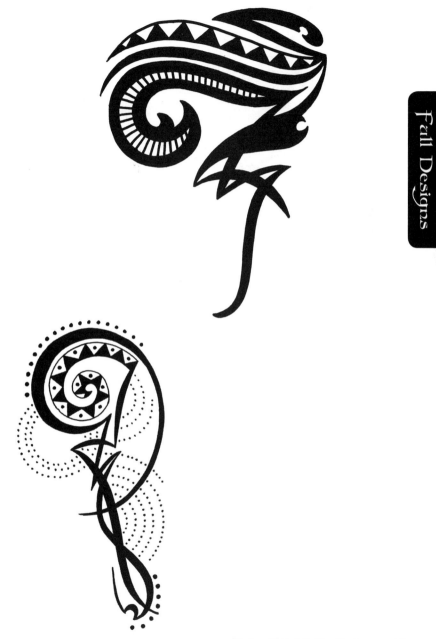

Free Form

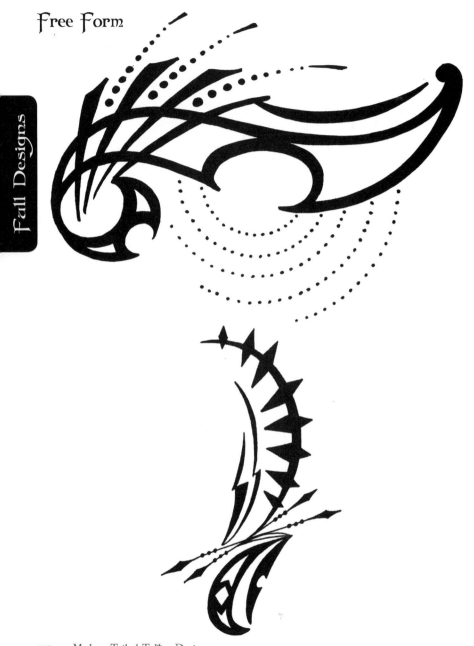

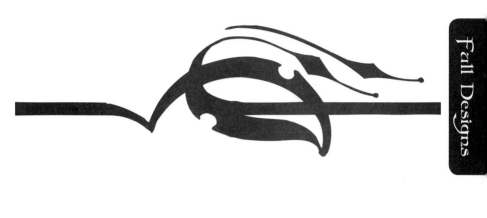

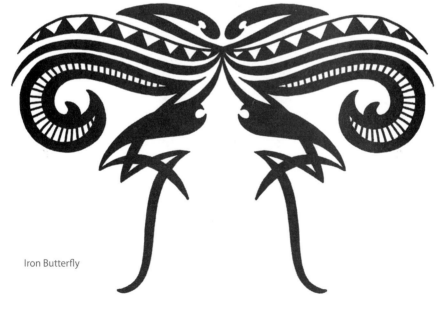

Iron Butterfly

Henna

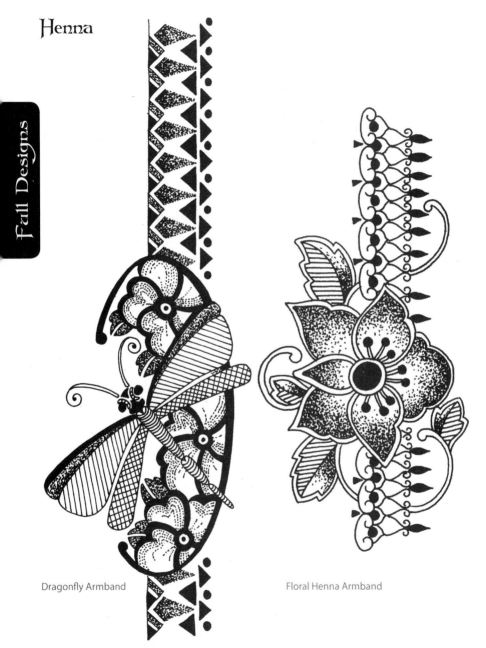

Dragonfly Armband

Floral Henna Armband

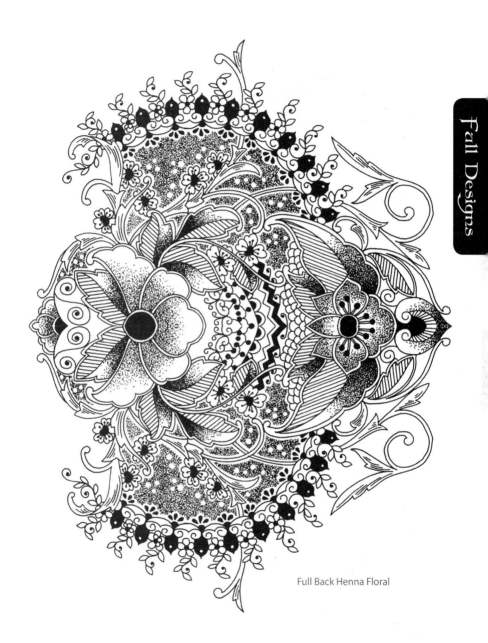

Full Back Henna Floral

Henna

Henna Ankle Line

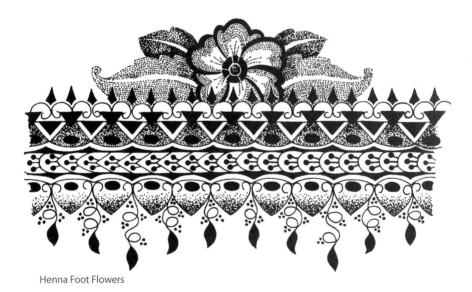

Henna Foot Flowers

Henna

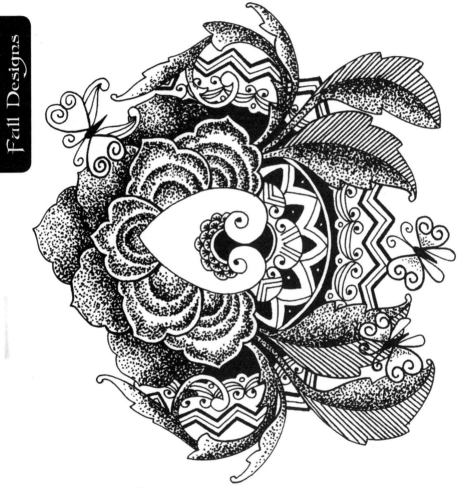

Henna Half Circle

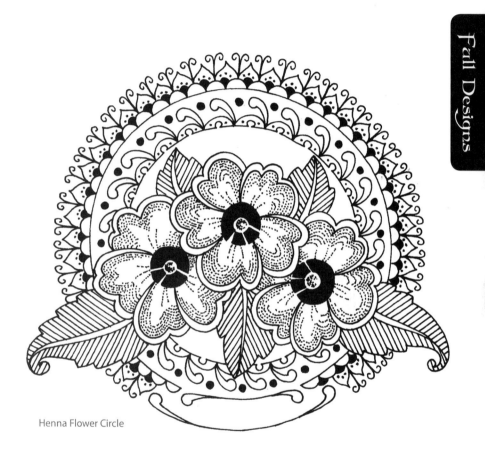

Henna Flower Circle

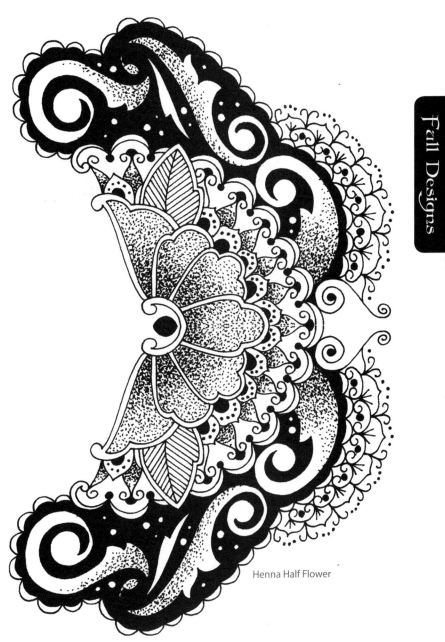

Henna Half Flower

Henna

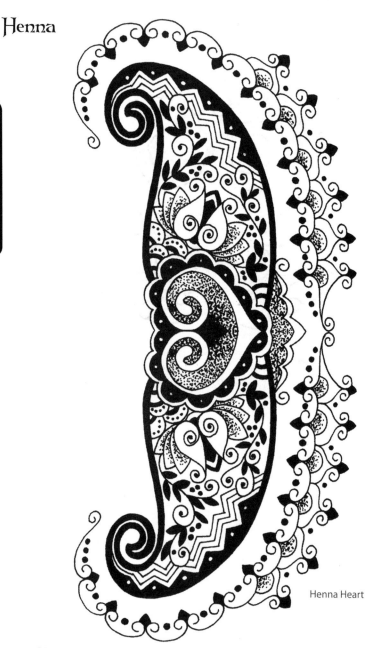

Henna Heart

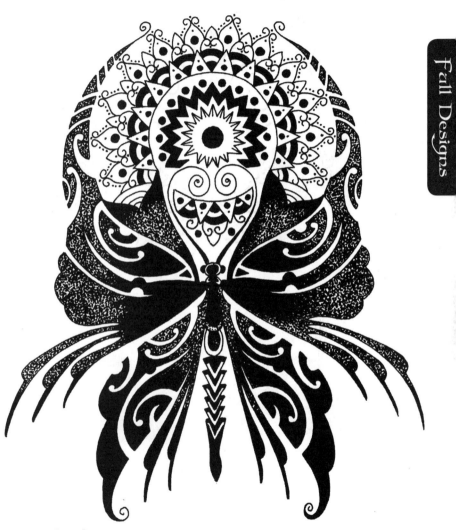

Henna Iron Butterfly

Henna

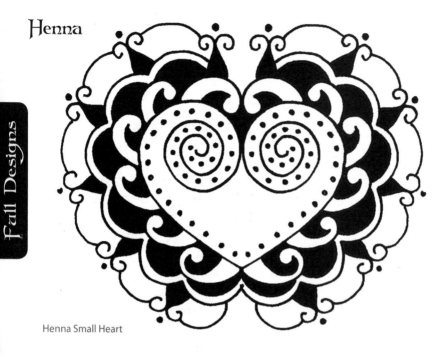

Henna Small Heart

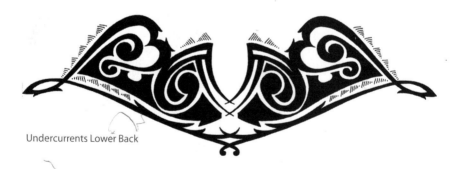

Undercurrents Lower Back

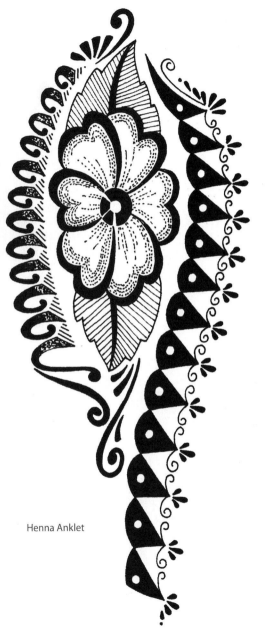

Henna Anklet

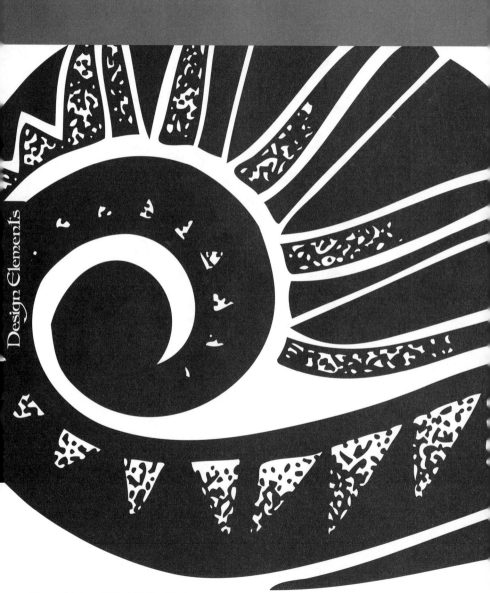

Design Elements

Design Elements

Like the designs in the previous sections, the following patterns can be used as is, especially for small tattoos. However, these designs can also be used to enhance other patterns in this book or in making your own tattoos. Both simple and complex grids are included to aid you in designing your own tattoo.

Line Accents

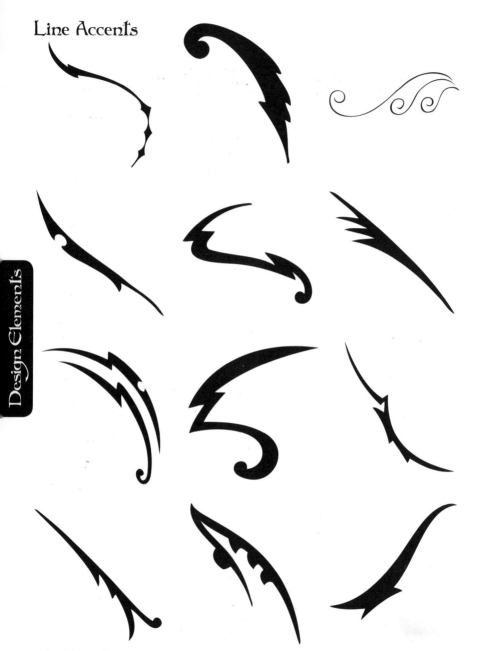

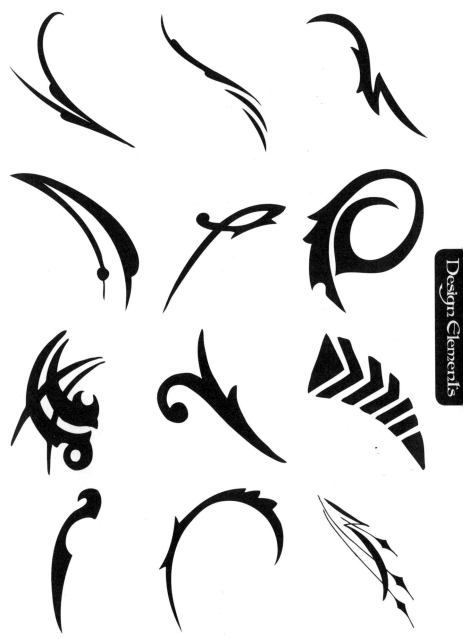

Line Accents

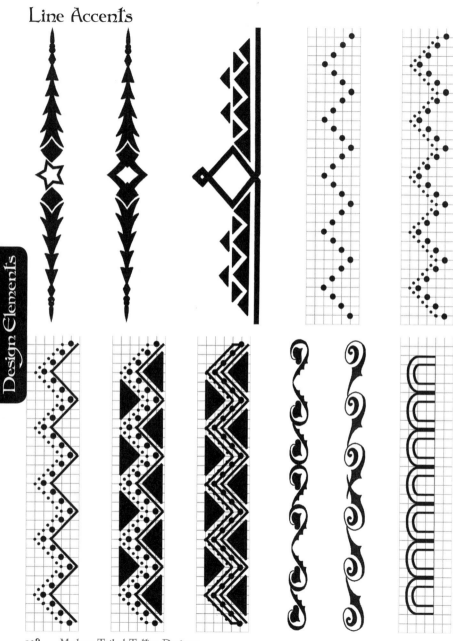

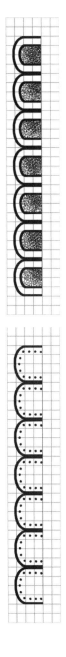
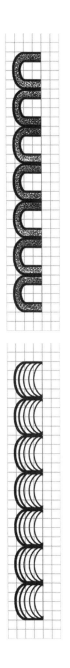
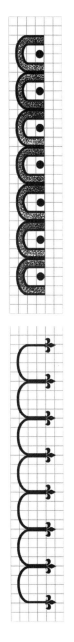

Line Accents

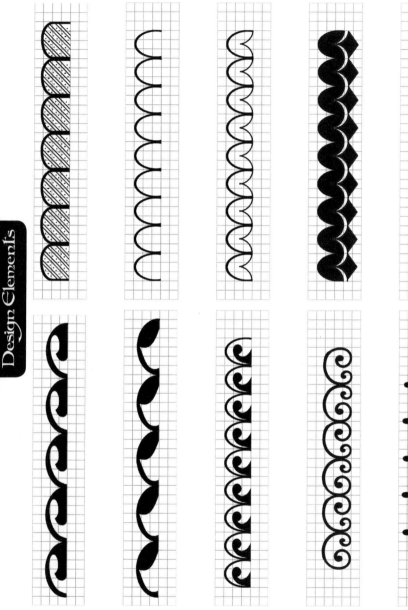

Line Accents

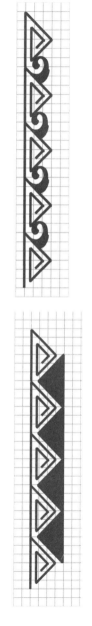

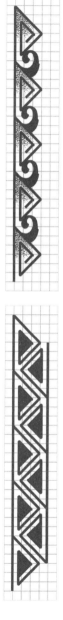

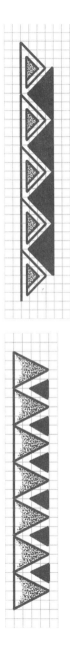
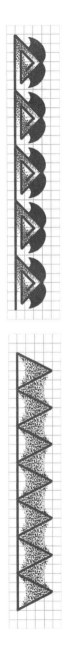
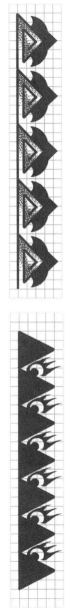
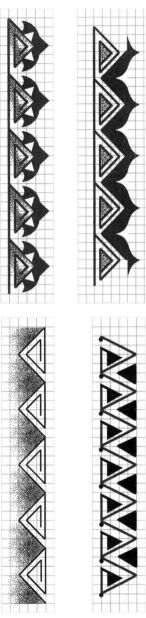

Line Accents

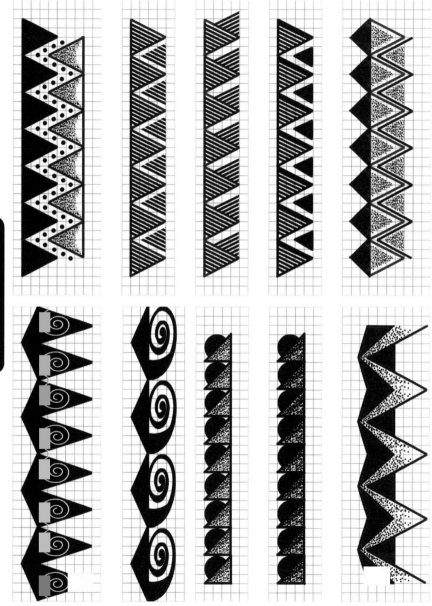

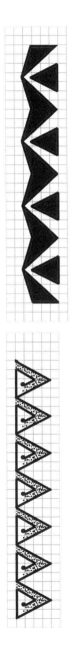
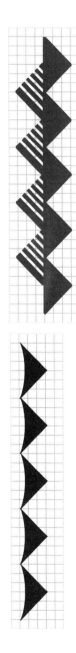
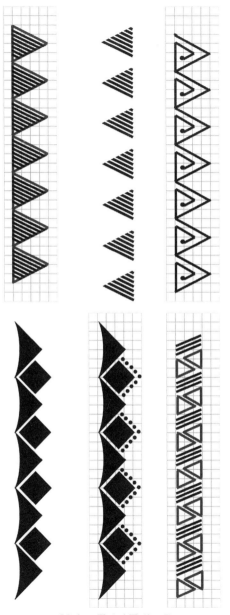

Line Accents

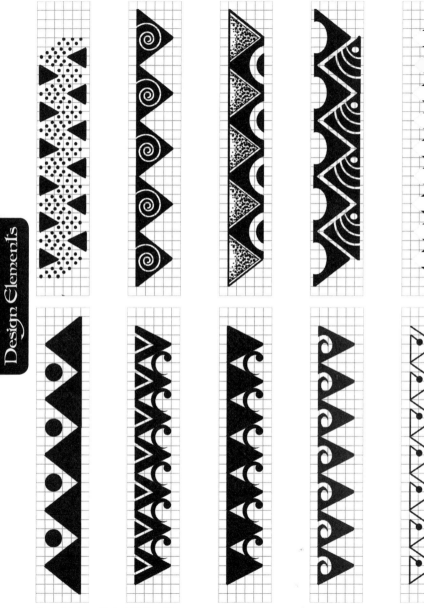

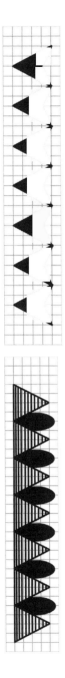
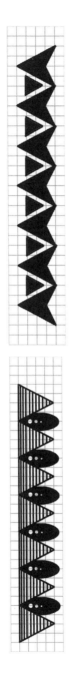
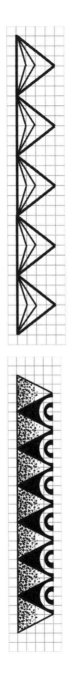
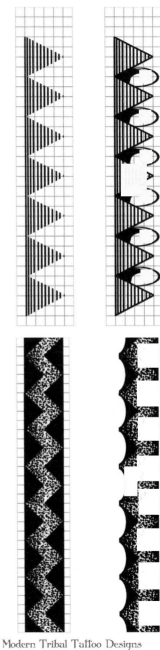

Line Accents

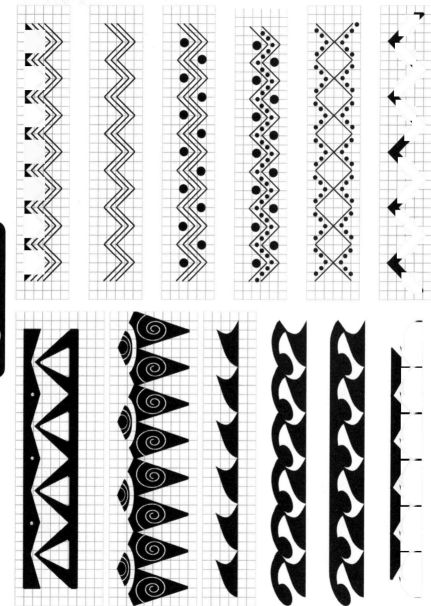

Spirals

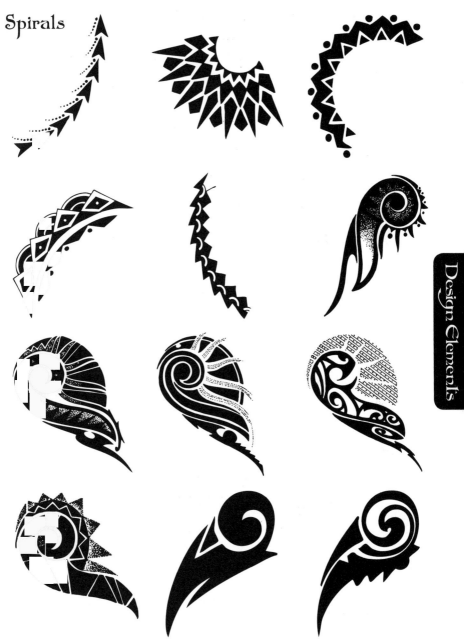

Design Elements

Spirals

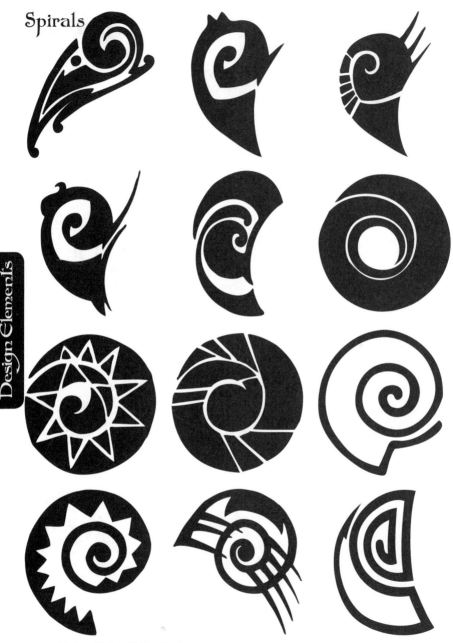

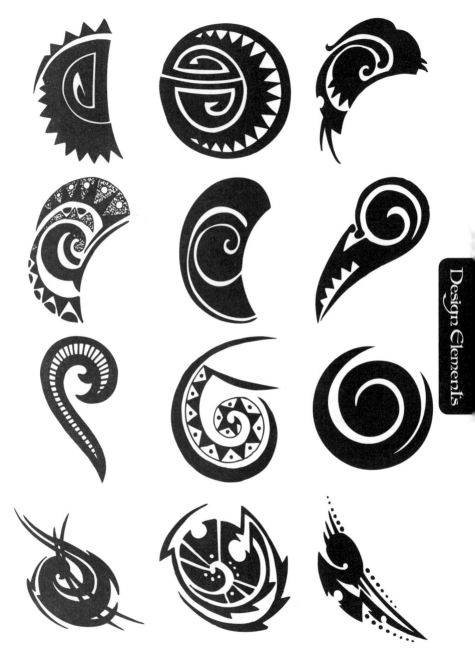

Spirals

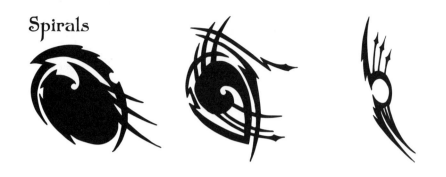

Grids

Square Grid

Triangle Dot Grid

Grids

Concentric Circles Dot Grid

Oval Radius Grid

Grids

Spiral Circle Grid

Oval Spiral Grid

Grids

Bent Triangle Dot Grids

More Great Books from Lora S. Irish